SUZANNE OPTON

SUZANNE OPTON

MANY WARS

ESSAY BY
ANN JONES

DECODE BOOKS

This first edition of *Soldier / Many Wars* is limited to 1,500 casebound copies.

The book was designed by John Jenkins III and Suzanne Opton.

The text is set in Avenir and Melior.

Photographs copyright © 2011 by Suzanne Opton.

Copyright © 2011 by DECODE, Inc.

Color mangement by iocolor, Seattle
Printed and bound by Shenzhen Artron Color
Printing Company, LTD., China

DECODE, Inc.
625 First Avenue, Suite 300
Seattle, Washington 98104
www.decodebooks.com

Available through **D.A.P./Distributed Art Publishers**
155 Sixth Avenue, 2nd Floor
New York, NY 10013
Tel: 212.627.1999 Fax: 212.627.9484

ISBN 978-0-9833942-0-4

A special **Collector's Edition,** consisting of either
Soldier: Mickelson–350 Days in Iraq from the *Soldier*
series or *John Kipp–Iraq* from the *Many Wars* series,
is available in a limited edition of fifteen with a signed
copy of *Soldier / Many Wars*. Please contact DECODE
for more information: **books@decodebooks.com**

FOR JULES AND SAM

I am grateful to the many people who made this project possible. To the soldiers and veterans who generously volunteered to be photographed and share their war experiences. To Jim Dooley, Andy LaCasse, and Andy Pomerantz, who believed in the photographs and opened the door. John Jenkins III for his patience, vision, and good cheer. Ann Jones and Phillip Prodger for contributing their time and talent.

To Susan Reynolds whose great inventiveness helped to bring the Soldier Billboard Project to life. To the billboard sponsors who made it possible for the images to been seen by a larger public—Ken Grossinger and Michelene Klagsbrun at Cross Currents Foundation, Diana Barrett at Fledgling Fund, Nathan Cummings Foundation, Central New York Community Foundation, New York Foundation for the Arts Foundation. Special thanks to Cain Claxton and Craig Birkholz and family for their support when we needed it most.

To my ever supportive colleagues at ICP: Phil Block, Suzanne Nicholas, Alison Morley, Buzz Hartshorn. To the artist-centric Light Work team: Hannah Frieser, John Mannion, Carrie Mondore, Jeffrey Hoone, Mary Lee Hodgens.

To the John Simon Guggenheim Foundation for the fellowship that allowed me to produce *Many Wars.* To Blue Mountain Center, MacDowell Colony, and Polaroid Collection.

Special thanks to Alison Bradley, Kathy Grove, Marcia Lawther, Peggy Nolan, and James Sprouse for their crucial insight and encouragement.

To William Ewing, Nathalie Herschdorfer, Christophe Blaser, Martin Parr, Vince Aletti, Vicki Goldberg, Marvin Heiferman, Patrick Amsellem, Charles Desmarais, Stephen Cohen, Rick Perez, Peter Hay Halpert, Chris Rauschenberg, Anne Tucker, Urs Stahel, Ronald Feldman, Stuart Horodner, Jack Becker, Janice Kaplan, Denise Meng, William Hennessey, Atea Ring, Blake Fitzpatrick, Jim Casper, Susan Hochbaum, Andrea Fitzpatrick, Lawrence Borse, Adriana Hernandez, Alice Rose George, Larry List, Thaira Hilli, Arwa Mustafa, Jane Arraf, Susan Sachs, Barbara Pizer, Chuck Kelton, William Nabers, Christophe Tannert, Christine Osiniski, Max Dworkin, Andrea Bichsel, Steve Skladany, Diya Vij, Evgenia Arbugaeva, Richard Brick, Sandra Edmonds, Liz Blum, Ed Sturmer, Stephan Petrik, Alex Danchev, Larry Tietz, Tobi Bergman, Susan Moldow, Stephanie Bursese, LaToya Ruby Frazier, and Muriel Dimen. To my brother Michael and my sister Helen, who gave me the pose.

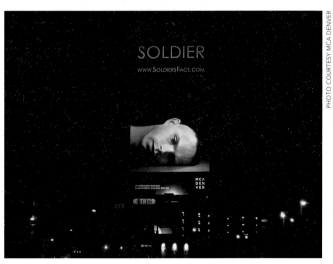

PHOTO COURTESY MCA DENVER

The Soldier Billboard Project in Denver, Colorado, August, 2008

SOLDIERS: WHO ARE THEY?

ANN JONES

I first saw Suzanne Opton's photographs of soldiers in the spring of 2010, only a few weeks before I was to embed as a journalist with the American Army in northeastern Afghanistan. I couldn't get Opton's images out of my head. In the summer of 2010, American forces were preparing for a major offensive in Kandahar, in southern Afghanistan; most American forces and apparently most journalists were there, in the south, waiting for historic events to unfold. But in the east, where I traveled to a Forward Operating Base, the war was understaffed, underreported, and "hot." On many days shells rained down on the base, soldiers fell in firefights, and the commander abandoned the pretense of "counterinsurgency" to fight what he called conventional war. There were not enough military helicopters to carry the wounded and the dead away. Yet to my knowledge, American media carried no news of events befalling these soldiers day after day when they ventured outside the wire to patrol a landscape of rocks at what must have seemed to them to be the edge of the world. On base, every soldier is attached to a "battle buddy," a cell phone, the internet, and international phones, but one look at that black high desert sky and it's hard to kick the feeling that you're nowhere, and you're all alone.

One day on the base I watched a sergeant mount in a black frame a color photographic portrait of a newly dead soldier. The sergeant held the photo at arms length and looked at it. In the portrait, the soldier's head was centered in the normal vertical position. A boy's slightly blurred face, squeezed between a high dress collar and an oversized hat, looked back at us from the shadow of the brim. The sergeant said, "It's too bad it's not a better photograph." He hung the photograph on the wall in the corridor outside the base commander's office, at the end of a long row of blurry photographs of soldiers recently killed. Such photographs are taken at the beginning of the soldiers' military career, when they have been stripped and shorn and thrust into uniform and learned to be proud of looking just alike. Thousands of pictures like this stand for years on dressers or mantelpieces in the homes of parents who try to look past the uniform, the hat, to find the boy or girl they brought into this world.

On the base, I used to sit in the DFac (dining facility)—a big tent banked with sandbags—and watch the soldiers show up for chow two by two, each man or woman accompanied by that inseparable battle buddy. They wore combat camouflage and tall blond combat boots. Strapped to their legs, strung from their belts, and slung from their shoulders were side arms and serious knives and M16s. The soldiers came in different sizes—short or tall, wide or wiry—yet they seemed to be identical. Under their helmets or camouflage caps, behind their ballistic wrap-around shades, they were anonymous. But I could sit across the table from a soldier hunched over breakfast, totally focused on the systematic two-fisted consumption of fried eggs and sausages and pancakes, and picture the soldier's head, uncovered, unmasked, disarmed, lying upon the table, illuminated by Suzanne Opton's lights. Only then could I think of saying, "Hi. How's it going?"

That's the startling thing—one of many memorable things—about Opton's soldiers. They do not look alike. In this collection, some are clad in nondescript fabric, suggesting a cloak or perhaps some timeless uniform, while others merely lay their naked heads, horizontally, before us. At rest? At peace? Dead? It has been suggested that Opton is not a proper war photographer—which, as far as I know, she does not claim to be—because her images are nothing like the action-packed "kinetic" combat photos we have grown accustomed to. Her stripped-down images omit the context we seem to need as viewers; without the captions—Soldier So-and-so—we wouldn't know that we are looking at soldiers. Without the uniforms and guns, without the tanks or planes in the background, we might think we are looking at ordinary people. Which, of course, we are.

I won't describe these photos to you. You can see them for yourself. But coming face to face with ordinary people—people like ourselves—we tend to project our own feelings and ideas onto the images, just as we often do when meeting people in real life. Even among art critics, or perhaps especially among such opinionated commentators, disagreements occur about what these photos look like. One says the African-American man identified as Soldier Jefferson is gazing "ever so slightly aggressively" at the camera. Another says he "looks

peacefully at the lens, . . . apparently at ease." I might ask you what you see, and then ask again if what you see is simply some aspect of yourself.

Because these photographs are so open, they may serve as a kind of Rorschach test to reveal to ourselves what we think about war—the enterprise in which these soldiers have been engaged. One commentator, a former military commander, writes of the photograph of Soldier Pry: "Here I sense a slight smile of satisfaction, of contentment. Deep in sleep, bone tired but a job worth doing has been well done . . . maybe he has found something within himself that he hoped would be there but only the ultimate test of battle would confirm." Maybe. But as a civilian who hasn't shared such an experience, I see in that face only the vacancy of a man who has retreated into himself, withdrawn from the familiar world.

In hopes of coming to know these photographs better, I put three of Opton's portraits on the wall beside my desk—two *Soldier* faces and one cloaked veteran of *Many Wars*—but whenever I turned to talk with a visitor seated in the armchair opposite, I found my guest's gaze slanting over my shoulder, locked on those images. Conversation stopped. "Sorry," a visitor would say. "I can't stop looking." And then, "Who are they?"

One commentator reviewing a show of the *Soldier* portraits said that "war is etched on their faces." I don't think it is, nor do most of my visitors who can't take their eyes away. These soldiers are young people, still seemingly soft and malleable. They are between tours of duty, moving on from one deployment, preparing for another. Etched on their faces is nothing much at all, or so it seems to me, for they aren't done with war, and war is not done with them. The images of the veterans of *Many Wars,* on the other hand, tell another story. Their wars are behind them, but their words, accompanying the images, describe the shards of war that stayed with them ever after; and their worn features also speak of hard living. It is as if war has etched their faces, over the years, from the inside out.

It is painful to imagine that internal corrosion of unforgetting at work in the young *Soldiers.* Opton herself tells a story about asking one of the young men she had

photographed what he and his buddies thought of the portraits. He said, "We thought the colors were kind of funny, and we didn't know where you were going with the poses." His answer left Opton wondering, "Is that all?" Hearing the story, a veteran of Vietnam explained, "They're still being soldiers. Show the photographs to them in ten years, when they've mourned about what they've lost of their lives, and then maybe they'll have something to say."

But if the young soldiers from the wars in Iraq and Afghanistan face the damage of lives lived by veterans of earlier wars, they are different from the older soldiers in one important respect. They are not the citizen soldiers who fought America's former wars, but rather members of a professional "all volunteer" army. In previous wars, our soldiers came from almost every neighborhood, if not every family, all across the country. In my own extended family, my father went off to war, and later two uncles, three cousins, and later still a boyfriend, a partner. (Three of those men did not return; the others did not return as themselves.) But today our soldiers are recruited in small towns and city centers in the South and West and the rust belt of the Midwest mainly from an underclass that finds few other promising opportunities in a strapped economy. These young people, many of whom come from families with a military tradition, step forward to serve the country with the same pride and perhaps even greater eagerness than the citizen soldiers of former wars; but though they serve the country, they no longer reflect the face of a diverse and democratic America.

For many privileged Americans, like me, our soldiers are somebody else's cousin, somebody else's partner. Today most Americans don't have to worry about full scale mobilization or the draft touching their sons and daughters, so we don't worry all that much about war—as long as it is fought by our "volunteers" and takes place in somebody else's country, over there. So it happens that although this country has chosen to fight two major wars in the past decade and is still enmeshed in the nation's longest war, with no end in sight, most Americans don't know a single active duty soldier. Here they are, in Opton's portraits—these strangers, these soldiers who go to war in our behalf.

War photographers travel to war zones to photograph the wreckage of war. Suzanne Opton went no farther than an army base here at home. She told an interviewer that she wanted to photograph the faces of people who had seen "unforgettable things." She knew that soldiers are such people, burdened by memories of war. The inescapable fact is that they bring war home. Hundreds of thousands of returning soldiers have been diagnosed with Post Traumatic Stress Disorder (PTSD), a condition that reflects a range of symptoms from hypervigilance to depression. Countless others have suffered the signature wounds of these wars: traumatic brain injury or amputations. Many have multiple injuries and are said to be suffering from "polytrauma." Perhaps such damage sounds more manageable in Greek.

Opton photographed the veterans of *Many Wars* wearing here at home the heavy cloak of war. Some of those veterans, enshrouded in that interchangeable garment of unremitting wars—WWII, Cold War, Korea, Vietnam, Gulf, Iraq, Afghanistan—try to tell us a little about what those unforgettable memories have done to their lives and the lives of those around them—their families, their friends, their communities. But many more, like Soldier Andrew Cotrel, cannot speak at all.

And so the young soft-faced soldiers take up the cloak of combat. In a curious way, never intended by the founders of this country who warned that a standing army is inconsistent with democracy, these young professional soldiers have now become the context of our lives, offering service to provide "security" to us civilians who may never get any closer to a soldier than the pages of this book: the faces—the faces of Soldier Jefferson, Soldier Pry, Soldier Claxton—in which we read our own conceptions of the wars fought in our name in faraway places to preserve what we still take pride in calling the American Way of Life.

Ann Jones, journalist and photographer, is the author most recently of Kabul in Winter *and* War Is Not Over When It's Over.

MANY WARS

I MADE THE MAJORITY OF THE *MANY WARS* PORTRAITS AT A
VETERAN'S ADMINISTRATION CLINIC IN VERMONT. MOST OF THE
VETERANS WERE IN TREATMENT FOR COMBAT TRAUMA AT THE TIME
WE MET. IN EACH CASE THE PORTRAIT WAS MADE AT OUR
FIRST ENCOUNTER, AND WE SAT DOWN TO TALK SOMETIMES AS
MUCH AS A YEAR LATER. IN AN EFFORT TO SET THE STAGE, I WROTE
THE PARAGRAPH THAT PRECEDES EACH PERSON'S OWN WORDS.

JIM DOOLEY VIETNAM

Jim Dooley served as a point man in Chu Lai, Vietnam, in 1968. For 144 days he carefully led his fellow soldiers through mine fields looking for Viet Cong. They never encountered the enemy, only the mines. Twenty-eight of his forty men stepped on one and lost a foot. His decisive moment came when he hit a trip wire attached to a grenade that had been covered in feces. Jim was riddled with E. coli and almost lost his leg. After multiple operations he was released from the hospital barely able to walk. But he survived and went on to become a counselor to veterans from many wars at a VA clinic in Vermont. In his mind's eye, Jim still sees a flying foot.

The difficulty of re-absorption into the civilian world is, "Who am I now?" That's why you see so many of these guys carrying weapons. Honestly, the most dangerous part is the first three to five months of post-deployment when they come home, when they're vibrating with dead dogs on the side of the road. All the triggers. Everybody has an image that haunts them. All of them. So they have to go to that image and they have to talk about that. But they avoid it like crazy. So it's this little dance. It's almost like, you know, pushing mercury around. The dropout rate in therapy is very high because they're really uncomfortable with confronting themselves. It's about forgiveness, a way of atoning. Most of the time they have guilt—that person had a family. That person had children. They don't know what to do with that. I talk with them about their doing something to honor that person. To do something. To make some kind of effort to atone. I think they can be healed. I do. The ones who can't are sociopaths, and they're not even in here asking for help. They're out there doing it again in a different version. But that's rare. Most of them are just like me—struggling fools.

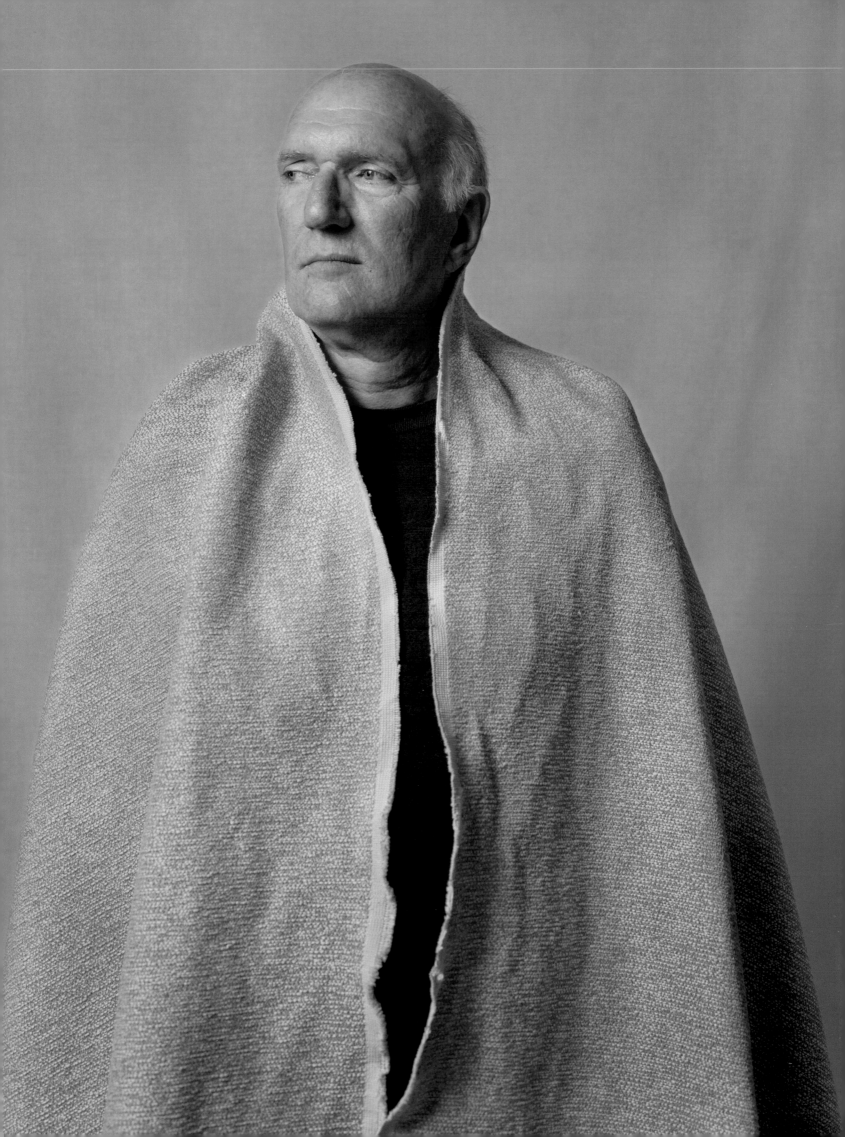

SHANNON BLAKE AFGHANISTAN

Shannon Blake wore a uniform for twenty years as a soldier, followed by ten years as a policeman. He believes we should all serve our country. He tries to follow in the footsteps of his grandfather who, Shannon says, "always did the right thing." After his medical retirement, Shannon considered law school, but he has difficulty being around people and realized the stress would be too much for him. So now he's earning a master's degree in digital forensics, a job where he can work alone.

I've been through a lot, I've seen a lot, done a lot. I had different missions, a lot of stresses. You're toughened up over the years and it's hard to think of yourself as weaker than what you thought. That was tough. I felt that I was mentally tough for the mission. And to come back and say, "I'm not as tough as I thought I was. I'm cracking here, and I need help." That's tough. I have my daily issues that I have to deal with—depression, anxiety. I'm medicated. There are several medications. Plus I came back with a respiratory problem and I deal with knee, back, and shoulder pain on a daily basis. I didn't have any health issues when I was deployed. I was fine. I was fit as a fiddle. To come back and have to deal with these issues—it's pretty tough. I thought I was physically and mentally strong and tough enough to handle anything, but I wasn't. And I need help and I received the help and I'm constantly receiving the help. It's not just that you get a little help and it's over with, and you can be on your way. I think it's a constant issue that you have to deal with.

When I left the service I felt like I was just a number. When I left, I thought it was just, "See ya later." And when I left law enforcement I felt the same way. It was almost like you were just dumped off and left alone. And that was one of the issues in Afghanistan—I felt that I was just dumped off the truck. "Figure it out. Here's the mission, figure it out. It's yours. You figure it out."

I think the military demands of you to be a better person. And I'd be proud if my daughter served. Especially today with the two wars going on. I'd like to someday see her serve her country. I'd be proud of that. It's not worth losing her, but I think it's worth serving. I think it's the right thing to do.

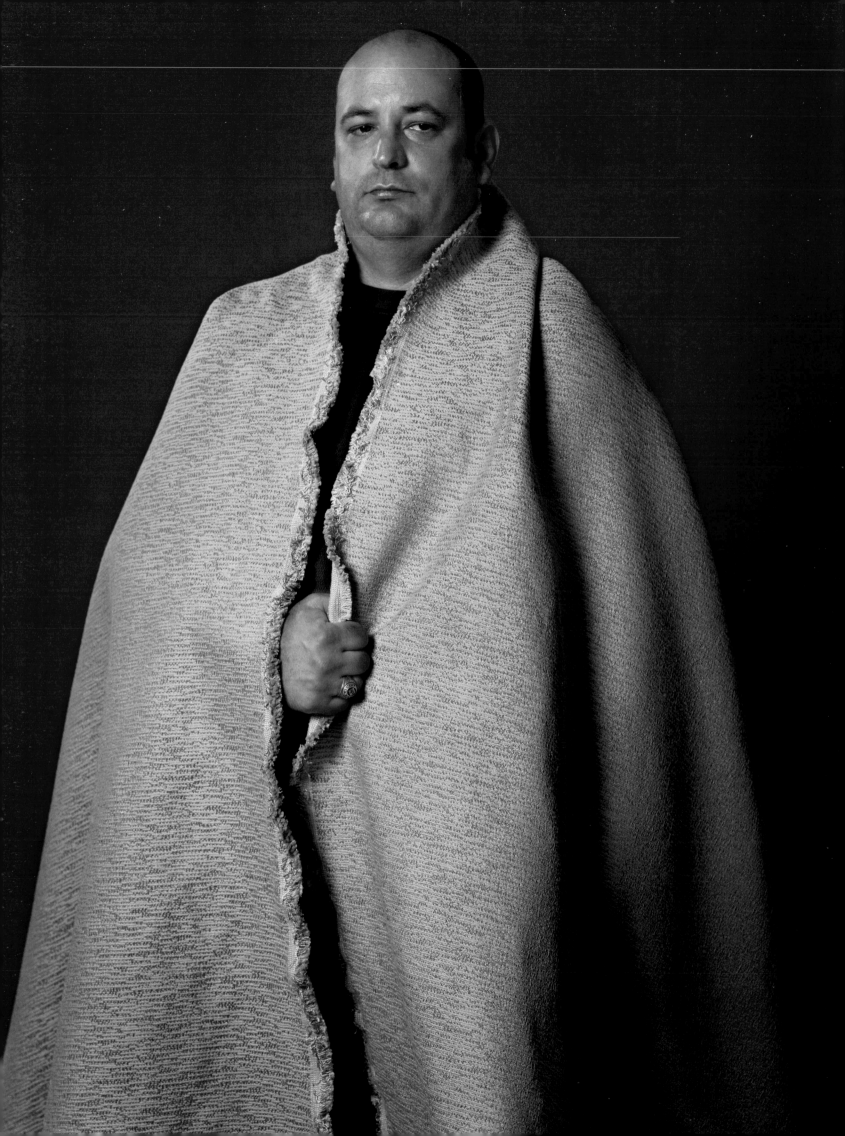

PIA TOWLE-KIMBALL IRAQ

Pia Towle-Kimball was the odd one in a family of liberals. She thinks maybe they shouldn't have been surprised when she joined the National Guard. Pia had college loans to pay off and the military offered a good deal. She came to respect its ethics and appreciated that people would die for her and she for them. It can be difficult for women, but the military has become her life.

The platoon sergeant was overheard saying, "Don't hang out with that female— she'll ruin your career. That's all females in the military do is ruin your career." It's very much a good-old-boy system. There are some higher-ups in leadership that are terrified to have a female under their command because a female might file a complaint and ruin their career two years from retirement. And honestly, it does happen. And there are females who will sleep with everybody they can. There are females who will file a completely bogus complaint. There are females who will sleep around and then claim rape. It does happen but not nearly as often as it's portrayed. You get these young females who've grown up in very insular communities and they've always been average looking, average intelligence, just average. And then you put them in a situation where there are twenty percent females and eighty percent males and all of a sudden they're a very hot commodity. Guys lavish attention on them. And if they haven't established their character, it's very easy for them to think, "Well this guy really likes me, and that guy really likes me." And the males definitely prey upon that. You see them picking and choosing from the new recruits coming in who they're going to make a pass at.

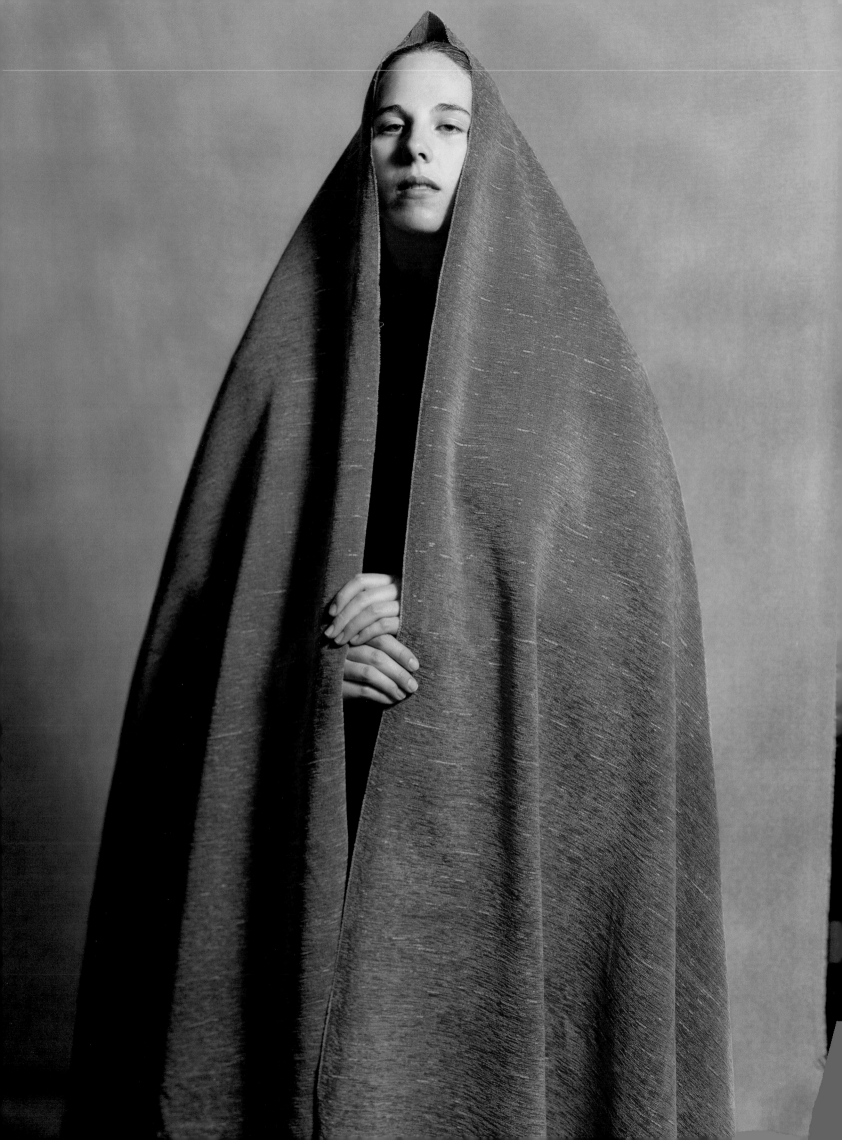

JOHN KIPP IRAQ

John Kipp was thirty-two years old, a high school teacher, and married with two kids when he joined the National Guard. He thought he would spend weekends helping with floods or building soccer fields in Vermont. In reality he became a patrol leader searching for improvised explosive devices (IEDs) in Iraq. A week before he was to return home, his vehicle hit an IED and John suffered traumatic brain injury (TBI). Despite his diminished mental and physical capacities, his former charismatic self is still very much in evidence. John is back in the classroom, and one imagines that students inclined to join the military might be inspired by his bravery and determination or might think twice when they witness their teacher struggling to get his words out.

I'm proud of what we did. We were out on roads finding bombs and disposing of bombs on roads that not only the military used but civilians, too. They say the average IED kills 4.2 people and we found 200 IEDs, so we saved 800 lives. And none of my soldiers were killed.

I was diagnosed with TBI and for me the biggest symptom is headaches. Some of the other milder symptoms are short-term memory, long-term memory, word retrieval—things like that. More forgetfulness. Usually by the end of the day I'm tired and worn out so there's not enough energy left over to do whatever. Teaching is pretty much it. Usually I come home, take a nap. It's been a strain definitely on my wife. Not only do I have all these physical limitations but also I'm a much different person than I was before. I was always a very active, happy person, very social. Now it's "I don't necessarily want to go out and see people or do things." Not excited about much, you know. "You want to do this? If you want to, fine." It's frustrating for her.

I was also diagnosed with PTSD. I'm on medication for depression, the basic anti-depression medication. Before I was on it, if something would trigger a depressive mode, I'd very easily and quickly spiral down into being very depressed. Now I might be depressed for a little while or something but it doesn't quickly spiral into a massive depression.

My students are good about it. They're very patient. There was one time I was standing in front of the board writing. The word that I couldn't figure out how to spell was "nut." And I'm like, "How do you spell nut?" There are always some who don't know, or some who think I'm kidding, and some who say, "No, he's serious. He was in Iraq. Watch out or he'll go PTSD on you." The kids said that once. It was pretty funny.

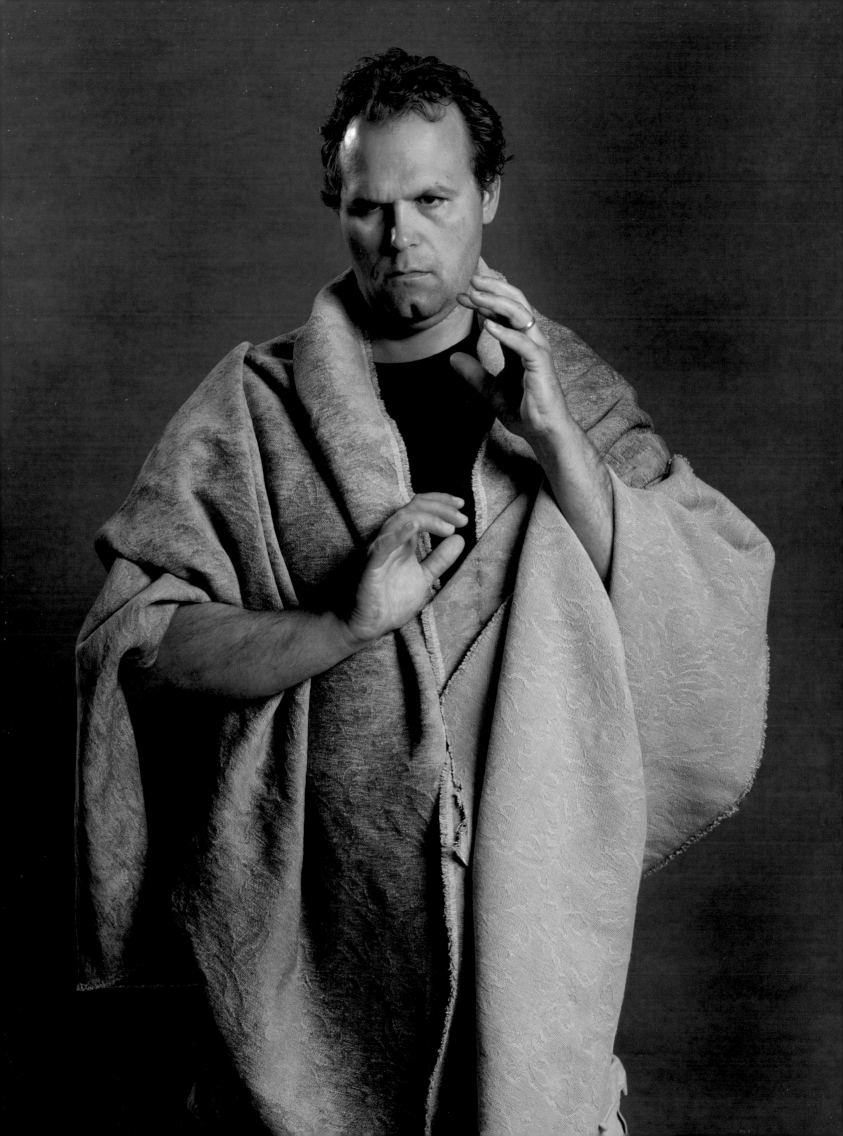

PAUL DANIELS VIETNAM

*Paul Daniels volunteered for Vietnam at nineteen because he thought it
was the right thing to do. One night during a missile attack there was
tremendous chaos and Paul lost control. When he returned home he drank
for ten months and was never the same. He says people thought he was
"a nut case"—anxious, angry, crying, depressed. He couldn't sleep for
years. Telling his story, Paul is unabashedly emotional, but he rises up
in his chair when he talks about what he thinks is right. Then he feels
strong. He thinks the war wrecked his life but he doesn't regret protecting
his country and is proud to have been brave enough to go. Paul takes
medication for sleeplessness, anxiety, and depression.*

It's difficult to go back thirty years, to bring up issues that I thought nobody
else would want to hear. Four times I tried to take my life—overdose of pills,
stopping at bridges, jumping off a bridge, driving in the woods not knowing
where I am. My family not knowing where I am. Finally I had a breakdown
and I ended up going to psych wards to understand what happened to me,
that it wasn't my fault.

I was in a bad attack. I was Sergeant of Arms one night and around 2 AM
the rockets were coming in. My duty was to make sure everybody had their
shrapnel vests on, their helmets, their combat boots, and when the alarm blew,
to get their M16s and be ready to go. But there was always that percentage of
GIs that would be drunk or high on drugs. They would be out watching the
fireworks and you would try to get these soldiers back into their hootches. But
it was very hard when they were under the influence of alcohol or some drug.
I was in charge of twenty-five or thirty hootches, with roughly ten guys in a
hootch, so a lot of guys to keep track of.

My basic thing was to make sure they were in their hootches. Those that didn't
want to get into their hootches, I told them the best I could. I wasn't about to
go and have a fistfight with these guys to get them back. Fifty people didn't
want to get under cover. They were out of control. I was doing my best for
what I was trained to do and these rockets were coming in and I lost it. Trying
to get all these gentlemen in and I just lost it. I screamed. Cried like a baby.
Out in the open. And I just cried like a baby. I had about five, six hootches
left and these rockets are coming. And I was out of control at that point after
twenty-five hootches. I kind of had my sense to about twenty, loosing it from
twenty hootches to twenty-five, and at twenty-five I knew that I was in a
situation I couldn't control anymore. I remember knocking at these last five
hootches and screaming "Please take cover. God bless. Please take cover.
God bless. Please take cover. God bless." And I ran back to the NCO office,
got underneath the desk, took my prayer beads out that my mother gave me.
Today it still affects me. All I thought was that we were going to be overtaken
and I just sat there in a baby-type situation cut off in a corner.

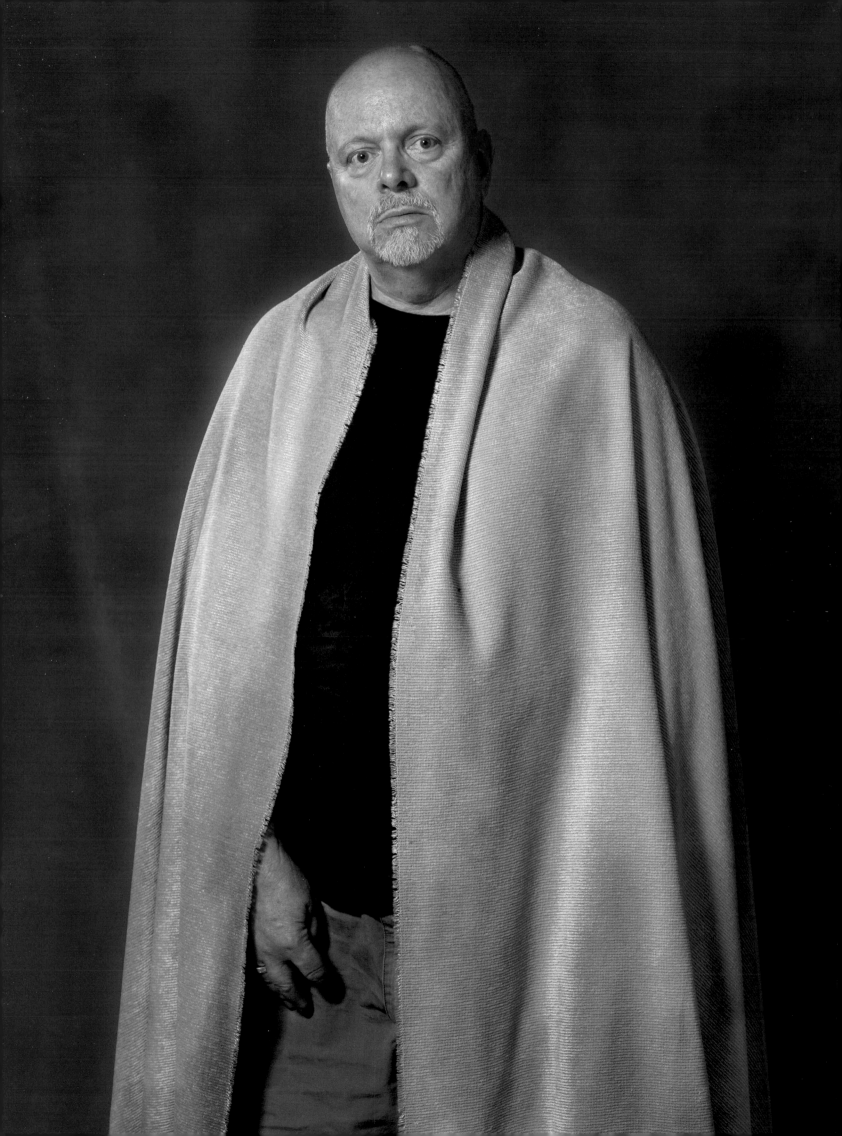

SHEA McCLURE IRAQ

*Shea McClure went to the recruiting office after high school and said
that he wanted to blow things up. The recruiter was quick to respond,
"Boy, have we got a job for you." Shea ended up in Baghdad clearing IEDs
from the side of the road at night. He loves the military and although his job
was stressful, he knew he was saving lives. It was much more meaningful,
he thinks, than any job he'd get back home repairing somebody's computer.
On first impression Shea appears to be the consummate soldier—cool,
sure of himself, on top of it. After the interview, however, Shea said he
was surprised: he thought he'd end up crying or something.*

I care about my guys. That's all I care about. I care about those fifteen guys
and that's it. I'm sure it's gonna piss people off, but I don't give a shit about
Iraq or Afghanistan. They could blow themselves up, fight each other, I don't
care. But as soon as you send some of my brothers there, that's what I care
about. That's what makes me care about the war. I'm going do the best I can
to bring those guys home.

A lot of people that were looking forward to going home in a month or two got
pretty badly hurt. It was just kind of demoralizing to see your buddy talking
about how he's going to go home and see his wife and now he's getting taken
off in a helicopter completely unconscious because he hit this IED on our
second-to-last patrol.

Then there were a lot of situations where when we were on patrol some guy
was doing everything right to justify us shooting him. If you see a guy digging
on the side of the road, it doesn't really matter if you don't see an IED. The guy
shouldn't be digging on the side of the road—shoot him. We were told this is
perfectly acceptable. Shoot the guy. Usually I'd rather be safe than sorry as far
as my guys are concerned, and I don't really give a shit about those other guys.
Shoot 'em. A couple of times where even though we were completely justified,
I just told my guys not to because I didn't feel it was necessary. Just because
we can doesn't mean we should. I wouldn't have gotten into any trouble, but it
just didn't feel right to the people to just go around shooting people digging on
the side of the road.

I took pictures the whole time. But I don't look at pictures. It makes me feel
uncomfortable and I kind of get quiet. Some people don't have any problems.
They put slide shows up, put up the music and all that stuff . . . get all excited,
and it makes me feel uncomfortable. I have them and sometimes I email them
to some people and say, "Hey, remember this picture?" But I don't go through
and look at all the pictures. I don't know if it's just going to drag some stuff up,
or if I'm afraid that I'll go back into Baghdad mode and it's going be tough to
get back out. It's two modes and it's tough to switch yourself on and off. Every
once in a while, like for me, it's tough to flip the switch. The switch is like half
on, so it's tough to go back to your old life. Even though you try, the switch is
stuck sometimes.

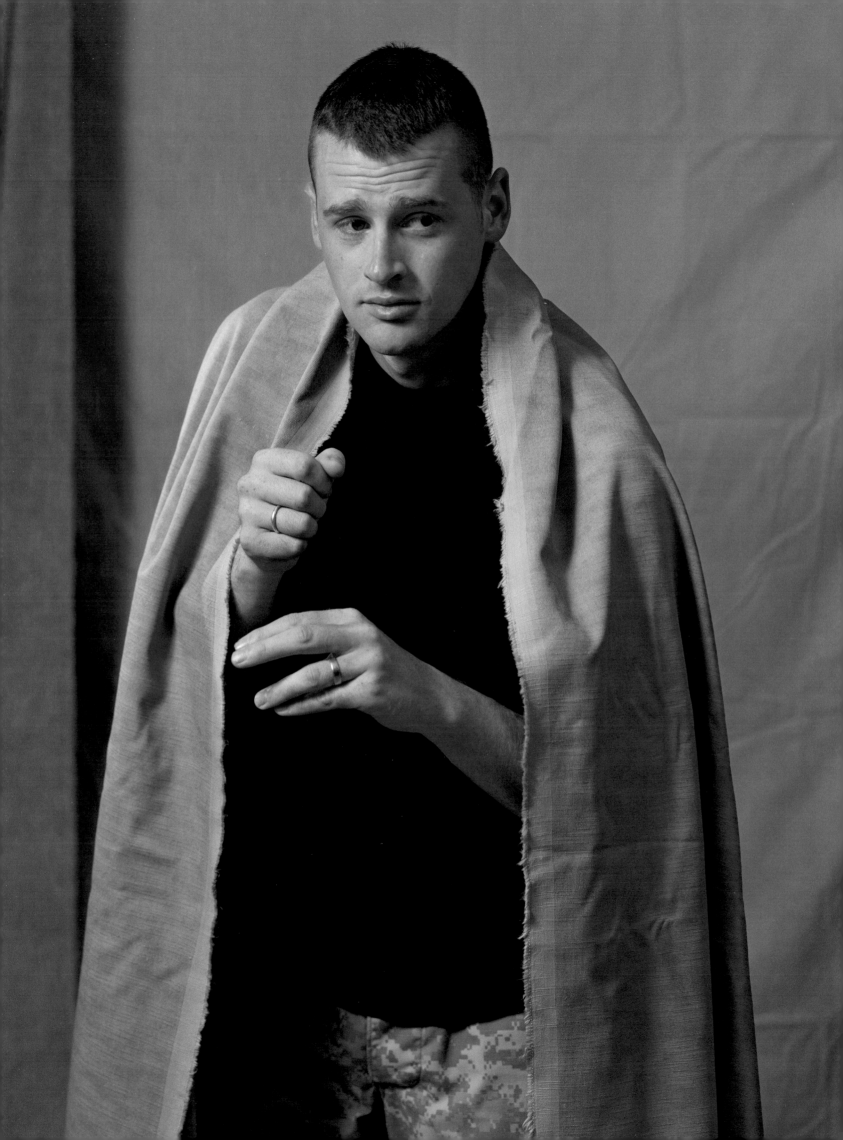

CLIFF AUSTIN WORLD WAR II

Cliff Austin was just nineteen in 1944 when the Germans captured him at the Battle of the Bulge. One might have thought that this kindly gentleman in his eighties was coming for therapy at the end of his life to finally come to terms with his war experience. But that is not the case. Cliff has not buried his pain; he had been crying for 60 years.

The German guards didn't let us out of the boxcars. There was no drinking water, no food, no place to go to the bathroom. It was very cold. Frost developed on the inside of the boxcar and we would take our tongues and lick the frost for a little bit of moisture. We ended up at a work camp in Nazi-occupied Poland.

We would work six and a half days a week, with picks and shovels, repairing bombed-out railroads. They'd give us what they called a kilo of bread and we'd have to cut it into seven pieces. I refused to do that job because you'd have six other guys starving to death, watching you, almost to the point of counting the crumbs. So there we remained and many of the guys died. It seemed like the ones who died first were the ones that were taller and had more weight. Typhus, starvation, malnutrition. It goes on and on and on. We couldn't wash ourselves, nothing.

There were three guys who kept talking about escape. We tried to talk them out of it, "You're going to get shot, you're going to get killed. Stay and suffer with the rest of us and the war will be over some day." But they did escape and we gave them little pieces of bread that we had hoarded. Jim Dunkirk was one of the guys put on a detail to go out and bring their bodies back. And Jim said that the three guys were in a seated position around a bonfire. And they were shot obviously point blank. They were roasting potatoes. They were starving. They must have gotten into a potato mound, put the potato on a stick, and held it in the fire. So the guys brought them back and they were forced to lay them at the entrance to the gate where we had to step over them to get to and from work. I remember covering their bodies with some coats out of respect. The guards would keep uncovering them. They wanted us to make sure to see our friends with the hole in the front of their heads.

When I first came home, I was in the hospital for I don't know how long. Then I went to work, but I ended up crying, without knowing what I was crying about. I'd go out to the warehouse and get behind a bunch of boxes where nobody could see me. And just cry and cry and cry. So I went back into the hospital. I came up with pretty bad dreams about death and being captured. Scared as hell. Dreams and fears. I still have fears. Some people can't sleep with a light on; I can't sleep if I can't see out the window. If I can see a streetlight nearby, I'm all right. My wife learned not to come into my bedroom and try to wake me up because I could choke her.

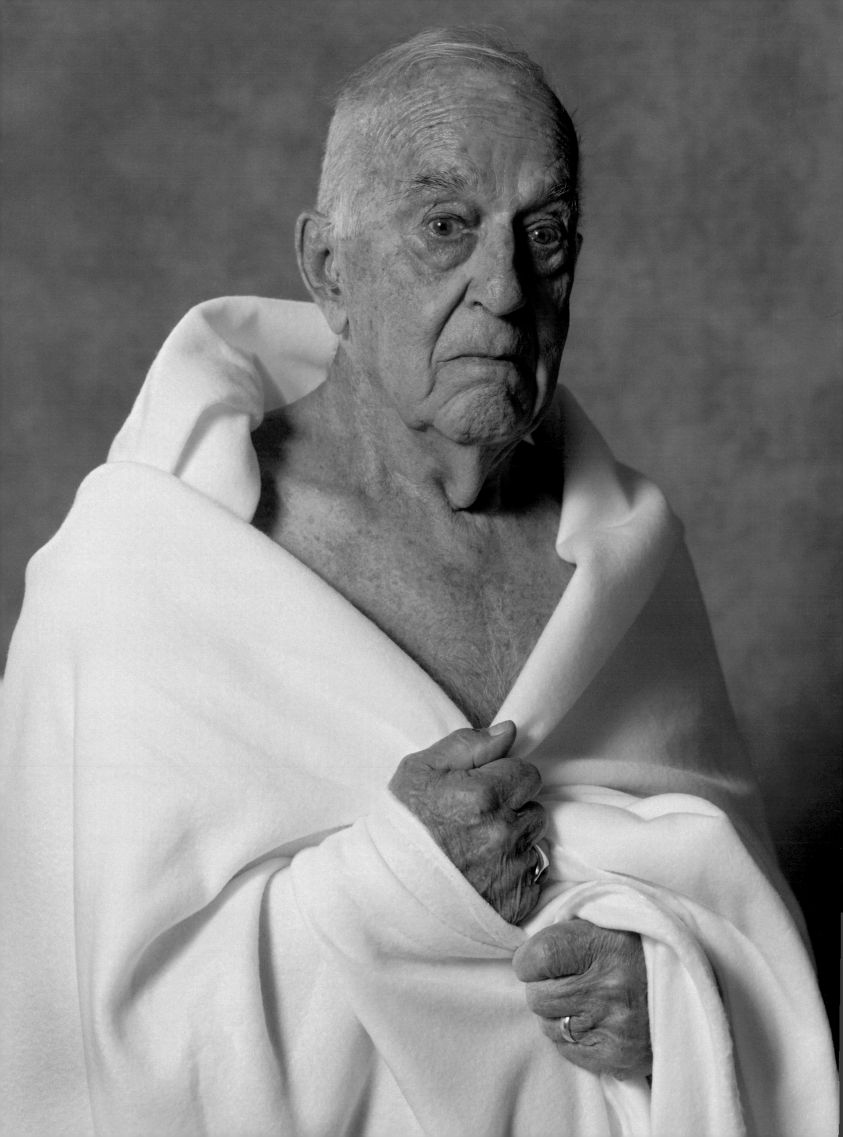

STEVEN HENSEL IRAQ

Steven Hensel joined the National Guard at nineteen and served two years in Iraq before he was medically retired for threatening his commanding officer. Steve is proud to have followed the family tradition of service that goes back to the Civil War. Now he's living at home with his parents and trying to figure out how to be in the world again. He can't be alone, he's heavily medicated, and many days he's too distraught to go out of the house.

Every day is a struggle for me. I would say the most uneasy feeling is walking around without a weapon in my hand. I'm not saying I want to walk around with a shotgun and hurt people. I just want to have it so I feel comfortable.

The first tour, there wasn't a day that went by that I wasn't shot at. It was like a blitz move in football. That's how we attacked the houses. A bunch of soldiers but they're a bunch of country boys. I drive them to the spot, they get the hell out, bum rush the place. I get out and I shoot anybody that tries to get in. I'm just full on gunslinger for a year straight. You know that's how we roll, that's how we got down. There was a lot of stuff we did that Bush allowed, that I don't think he should have allowed. That first tour was like, "Here's your license to kill." When you're nineteen you don't know better, you think it's cool to do that stuff. But as an adult at twenty-eight, I did a lot of crying over it.

I won't be able to go back into the army again because I can't follow orders. That was the problem with a psychotic break. They took my weapon away from me. And then they forced me on medication. I don't even know all the names of my meds because my mom does that. She takes care of my finances and my pills because my focus isn't there anymore. And I struggle with the fact that I'm not going back into combat. My mom pretty much told me that if the States ever get attacked just protect the family. But if the States ever get attacked then I might call a recruiter and I'll be like, "Are you still sure you don't want me?"

I was different after that first night when I saw a local with his brains plastered all over the sidewalk. We took out seven people that night. It was really ugly. I'd just turned twenty then. It changed me because a guy got shot in the head and we put him on the back of the bungalow and got him to base and we kneeled down like he was a deer and took pictures. It was mostly country boys like myself. That's what you do when you kill a deer. You take a picture of it, you grab its horns. And that's what they did, so I joined in. It's kind of a warrior thing to do. But it's disrespectful. You shouldn't do that to somebody. I told my buddy I didn't want the picture. Having the mental picture is enough for me. I used to see his ghost when I slept, and he used to be in my truck with me when I was driving, just staring at me. Jim [Dooley] told me to tell the ghost to go away. And I jumped out of bed on my feet in a fighting stance and told him to go away and that was a year ago and I haven't seen him since. I hope he understands I didn't mean to do that to him and he's forgiven me.

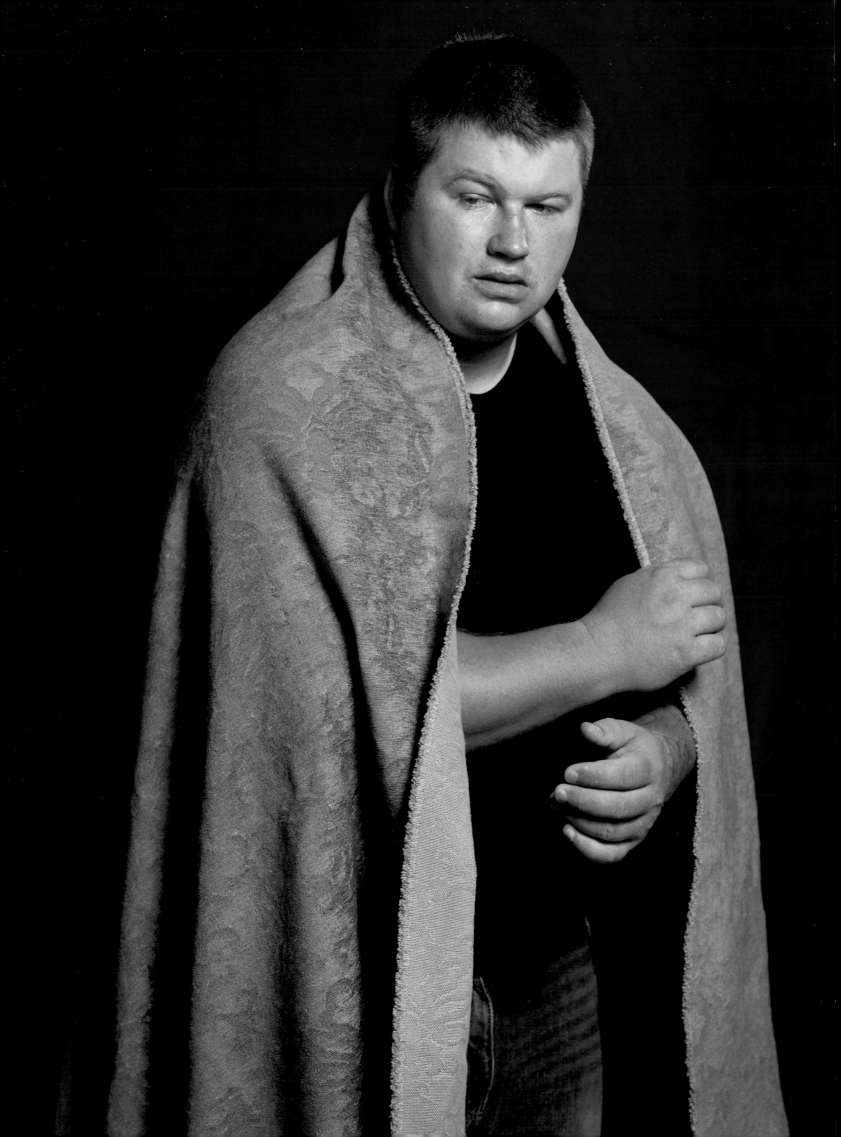

CHRIS KEELTY VIETNAM

Chris Keelty's family has a generations-long record of military service. Even so, his father threatened him with disinheritance if he volunteered for Vietnam. Now Chris says he wouldn't want his children to serve either, but at 19 he was anxious to defy his father and to learn about Asia. He has held many jobs but what he loves most is teaching a small class in English as a second language. Chris describes himself as a bit of a recluse. His house is relatively isolated. He and his wife are fascinated by ravens and believe in their intelligence.

We used to joke when we were over there that we were fighting for U.S. Rubber and Coca-Cola. Could the government honestly think Vietnam was a threat to us? We can incinerate the world multiple times. There's some other dynamic going on here. It probably has more to do with control of the world's resources than anything else. And when we got there I wasn't sure what our role was. We were mercenaries, pure and simple. We were over there from another government to prop up a government that we created. Diem was appointed by our government and subsequently assassinated by our government. I could rationalize because I was getting paid. I'm regular army, a mercenary. I didn't want to shoot anybody. I was there to evaluate, see what their country was like. That was personally why I was there. But how do I justify that with the fact that I'm a machine gunner on the boats. That's a tough one. It's something that I've probably never fully dealt with. There are a lot of things I still haven't expressed. I just submerged everything.

You see horrific scenes that are beyond comprehension. You see bodies floating in the river. We went to retrieve the body of one fellow and when we pulled up we tried to lift him up. You couldn't see any dog tags and all of the flesh just shucked right off his hand. There was a horrible, horrible odor. The hand was just skeletal at that point with just some shards of crap on it. It just went down in the water. They ended up putting a clip of ammunition into the guy to sink him. So there's an MIA.

The senselessness. I mean, what the hell's going on here? Why is this happening? Why is any of it happening? So many lives are impacted directly or indirectly. People come home, their families don't know what the hell to do with them. A lot of Vietnam vets never really had a chance. Fire your weapon for twelve months, go home, and be normal. Everybody who went over there was impacted just like everybody going over to Afghanistan is going to be impacted.

I don't feel pain. I don't feel a deep sense of hatred. I don't feel a deep sense of love. It's all very narrowed down and neutral. To feel the positive side, you got to do the whole thing. That's what I'm working on. Things don't affect me very much at all. After forty years of having developed this shield, to try and break it down now is . . . I'm working on it.

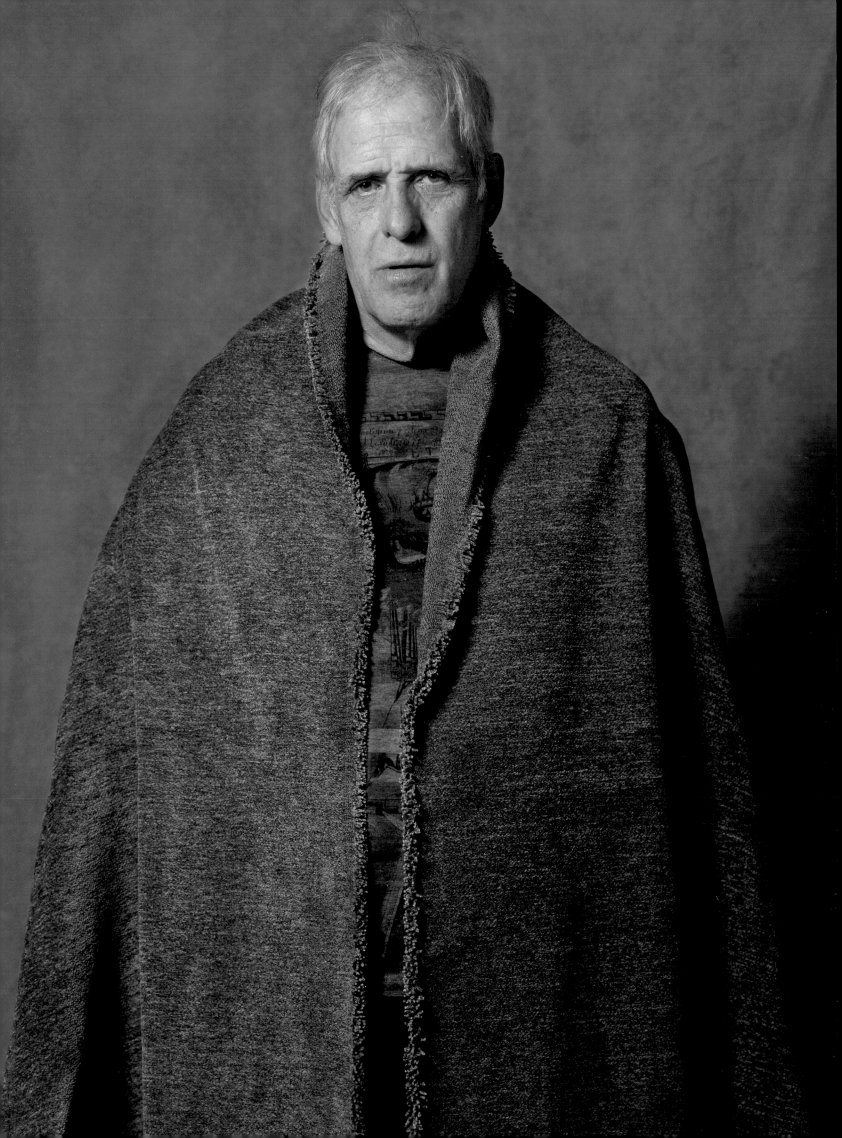

JAY WENK WORLD WAR II

Jay Wenk is eighty-three years old. He grew up in Brooklyn and joined the army in 1944 at eighteen. He didn't come from a military family, but during WWII joining up was simply expected. It was not until 9/11 that he began to understand the lingering effects of his service. Jay is on the town board where he lives and at the opening of monthly town meetings he refuses to join in saluting the flag. He's a combat veteran. He feels he has the experience to back up his antiwar beliefs.

When I enlisted, I was thrown into the company of older men. I was very shy and insecure. The other men accepted me as an equal, as a soldier, though I never felt an equal. When we were under fire or when we were attacked or being attacked, I was scared shitless. You learn quickly when you're under fire that it's more dangerous to freeze in one place than to get up and fight.

There were many involvements with German civilians, some of which were so demeaning to me and to the Germans, too. One time we had just taken a small town. We were going to stay that night in a cottage at the far end of town because we would be continuing the next day. About dusk, the sergeants showed up with seven women who were willing to sleep with us for cigarettes, chocolate, chewing gum. I had never slept with a woman before and so that experience was strange. I didn't know what to do. The woman took care of everything, but what made it memorable in a bad way was that early the next morning the guy on guard woke us all up. He saw a patrol of Germans in the woods on a little hill nearby. And so we all went running out up there. We went up the hill. The Germans had disappeared by that time, but we were shooting into the woods anyway just in case.

We came back down the hill and the cottage window was full of the faces of the women that we had been sleeping with the night before. For me that was horrible. I couldn't help but wonder, "What were they thinking? What were they feeling?" Here we were looking to kill or capture their people, and they had slept with us for the goodies we had and they wanted. And I felt guilty and sick about it. It was in its own way as horrible as being under fire.

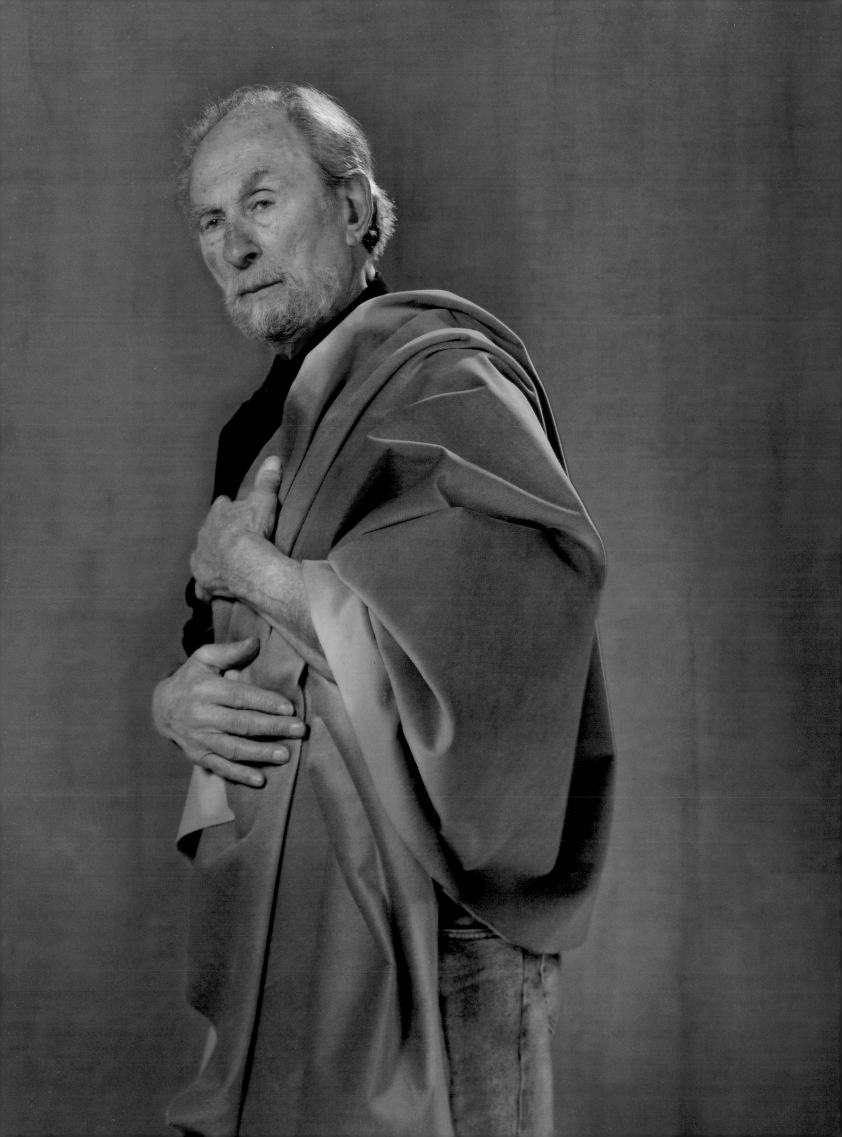

MIKE BRENNAN THE COLD WAR

Mike Brennan served on a ballistic missile submarine in the North Atlantic for three months at a time without surfacing, constantly ready to launch nuclear weapons if the U.S. were attacked. When Mike left the service, he went to college, got married, worked as a journalist, got divorced, started drinking, lost his family, became homeless, camped on another veteran's couch, and eventually became a counselor in a facility for homeless veterans. Mike is committed to helping other veterans as they have helped him, but he's burned out from running the facility and looking out for the guys. He hasn't seen his daughters in twenty years, but they recently found him on Facebook.

It's pretty cool. Things you do in the service are pretty cool. Some things you do in the service are pretty horrendous, but you shrug it off because it's part of being cool and you're young and indestructible. So you think you're doing a vital service. We would get a radio message that would announce the beginning of a nuclear war and we never knew it was a drill. We called them end-of-the-world drills. We were never in actual combat, but we were always on a war footing. We were always on alert, hyperalert, hypervigilant. You're trained to a very high standard. It's like a razor's edge, literally. We would go through this whole process of launching missiles up until the point of actually launching a missile and then sometimes we'd sit there for hours not knowing. Because if we launched our missiles, everything back home was pretty much gone. That kind of weighed on your mind the longer you sat around thinking about it. So you just didn't think about it.

You get out of the service and people ask you what you did, but in my case a lot of it was secret so you couldn't even talk about it. So you hold that stuff in for a long time. It took a long time—a couple of decades—for me to realize that I had some problems and they led to substance abuse, alcoholism, and eventually homelessness.

And then there are the guys that never come in, who camp out. The VA gives them sleeping bags and tents and cold weather gear and boots and stuff. A lot of Vietnam veterans are still out there. They got treated bad by the VA a long time ago and they won't have anything to do with it. Frequently what happens is their health fails and then they come into the system, get treated for something physical, and then they get more involved and it helps them. Other guys turn right around and go right back out again. There are guys out there that die. They won't come in. Guys that bring the war home with them and they can't get out of it.

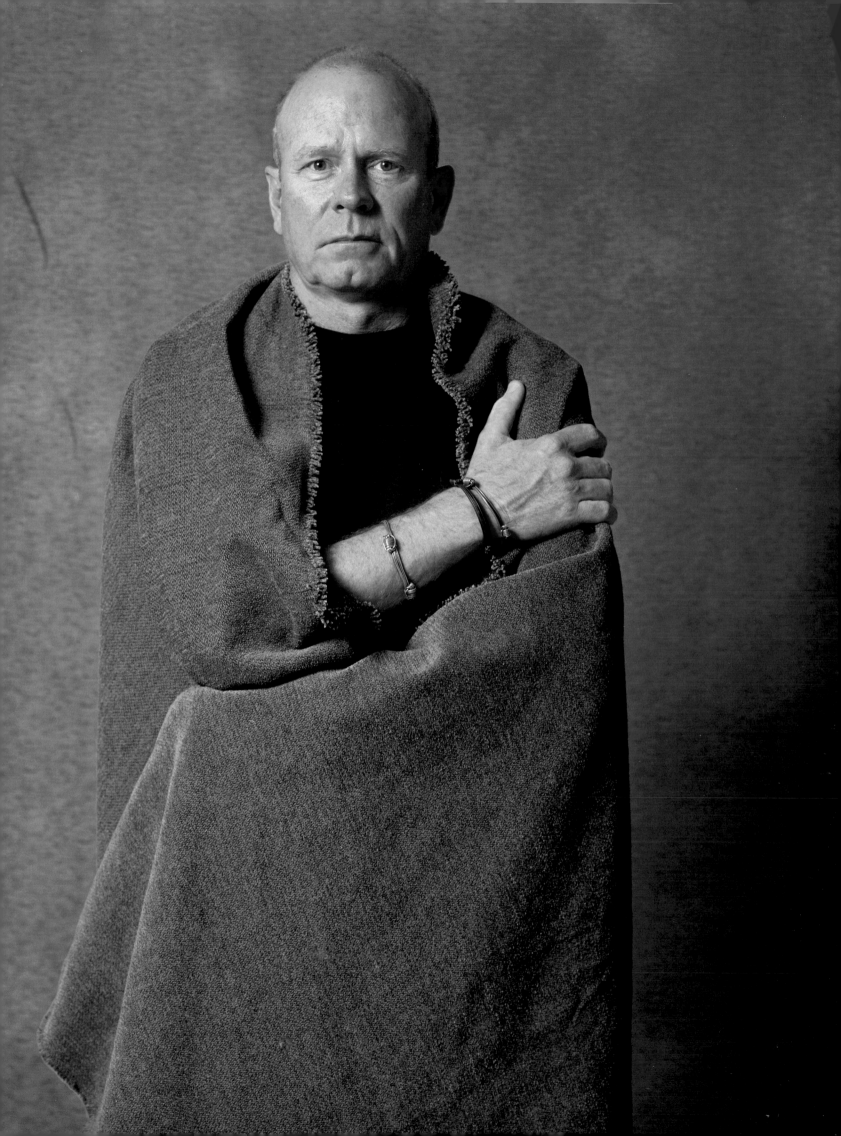

BOBBY HICKS THE COLD WAR

*Bobby Hicks was shuttled between foster families as a child. With only
a seventh grade education, Bobby is very articulate. He volunteered for
service in 1979 and served in Germany where he shot and killed an armed
man who trespassed on the missile site he was guarding. Bobby speculates
that he might have been a member of Baader-Meinhof—a German urban
guerrilla gang. He's not sure. Bobby was rushed back to Washington and
interrogated for killing a German national during peacetime. Bobby said
he was doing his job and he was returned to his post.*

*In 2002 he was drinking heavily and living in a homeless camp in
Seattle where he befriended a young man writing his master's thesis on the
homeless. Eventually Bobby turned up on this guy's doorstep in Vermont.
Now Bobby has an apartment not far from the VA and he's grateful for a
supportive community. He lives on $840 a month and the VA provides him
with a dozen different medications to keep him on track. Bobby is organiz-
ing a veterans march on Washington to protest the current wars.*

What I'm doing now I'm trying to get the word out. . . . I have had correspon-
dence, not as much as I'd like, but this has to be done right. People have
asked me, "Well, do you think this is going to be a political hotbed?" You
better believe it. The Veterans Affairs in Washington, D.C., even called me and
told me to cease and desist. You think that doesn't get my temperature up?
So obviously somebody has been alerted. I'll be quite frank, I don't give a
goddamn whose political toes I stomp on. Not step but stomp. This is
something that I'm passionate about and I will go to the grave with. We have
veterans coming home from combat now, men and women, who have suffered
far more than I can ever imagine. Not only are they coming back physically
maimed but they're coming back mentally maimed with things that I have
never seen, that I don't wish to see. I can't imagine. I've seen charred bodies.
My four comrades. But that was in a peacetime. These men and women are
putting their lives on the line every day, every day. And I have nothing but the
utmost respect and gratitude for my fellow service members, for what they're
doing now. What really gets my ass is a lot of people in government are
turning a blind eye and not caring one way or another. That's the crime of it.

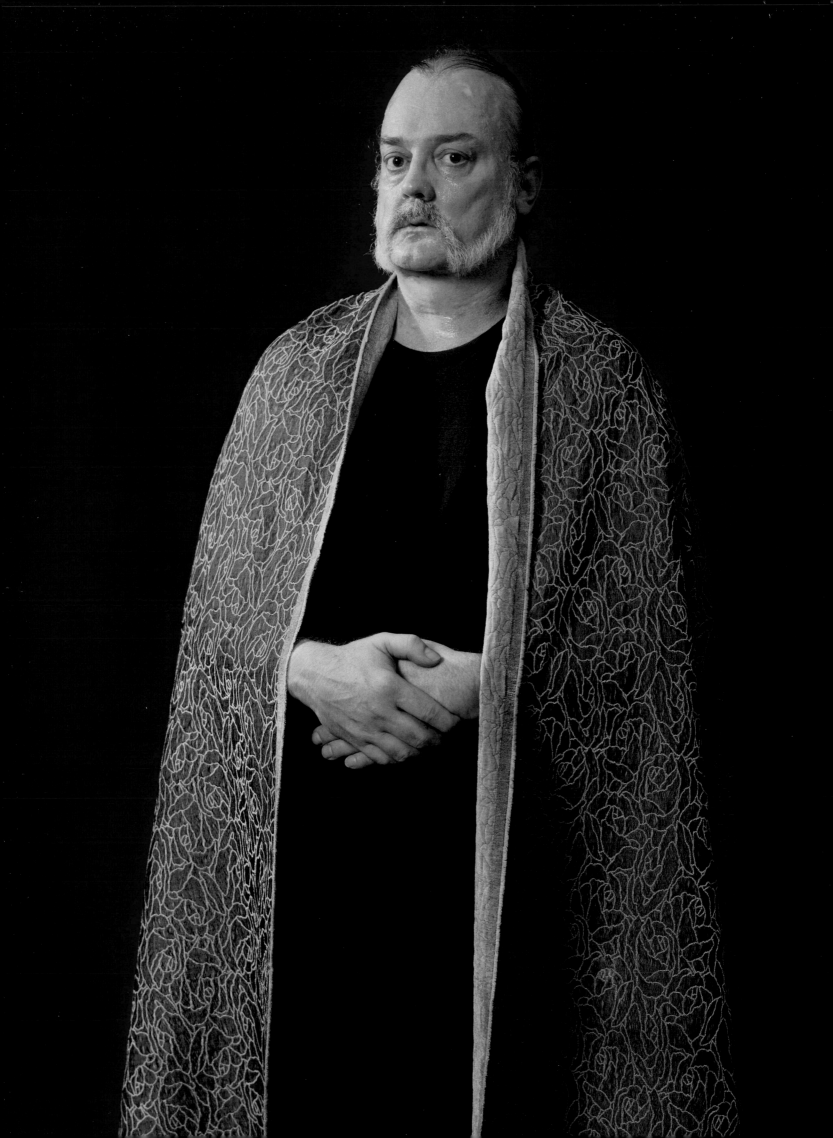

MARVIN ZACHARIE VIETNAM

Marvin Zacharie is a great storyteller, which is at odds with his insistence that he can't be around people. But Marvin is a man of many paradoxes. He may charm people by his gift of gab, as he calls it, but in the end most would rather settle with him than mess with him. A Mohawk from Canada, Marvin volunteered for the infantry in Vietnam. He says Mohawks are born and bred warriors, but he thinks his experience in Vietnam is respon- sible for his temper. Marvin is now on medication and he's calmer. Marvin always carried guns before his son confiscated them. Now he only carries knives. Marvin doesn't intend to be an innocent bystander.

We got mortared every day. Being mortared was like you take a shower every day. It's just another day . . . it's part of it. You accept it. I guess you're immune to it. It doesn't bother you because you can sit right down and eat with bodies lying around.

When we went to meet with the government, they would always ask the Grand Chief, "Are you bringing Zacharie? We hope you don't." Because I gave them hell. I loved it. I hate being around people. I can't be around people a long time. Five minutes. They're laughing, they're making noise, they're . . . I can't take that. I just get up and leave. I get excited. I get mad. Before we'd start any meeting the first thing the Grand Chief would ask me is, "Did you take your pills?" They always made sure. All the chiefs always made sure I took my pills. Because one time I was in there, somebody said something I didn't appreciate. I stood up so fast my chair went that way and I went right over the table after him. He never came back. He took off out the door and if they didn't stop me I would've hurt him.

I was mad at the world and it was getting worse. I'm talking on the phone and I pulled up right in front of the school and I'm talking on the phone. The phone kept losing the signal. I got out of the truck, I threw the phone on the ground, grabbed my hammer from behind the seat, and I beat the hell out of that phone. And then while I was doing this, I looked up and here's these young kids standing there watching me. And I didn't know what to do. I put the hammer back in the truck, I got in the truck, I turned around and went to the hospital. I said, "I got a problem." I shocked them, I think. Especially using a hammer to beat my cell phone. That's why I went to the hospital.

So I'd rather just be by myself. I go in the bush and take my mowers and my cut- ters and that's where I stay. I have all the bush cleared out, just like we used to do in Vietnam. Clear everything. I have a good field of fire right around. Because I might need to. I'm always clearing. I can see who's coming, I can see who's leaving. There are some trees. I don't take everything, but I can see right through everything. I like to be ready. Always be prepared. Prepare for the worst.

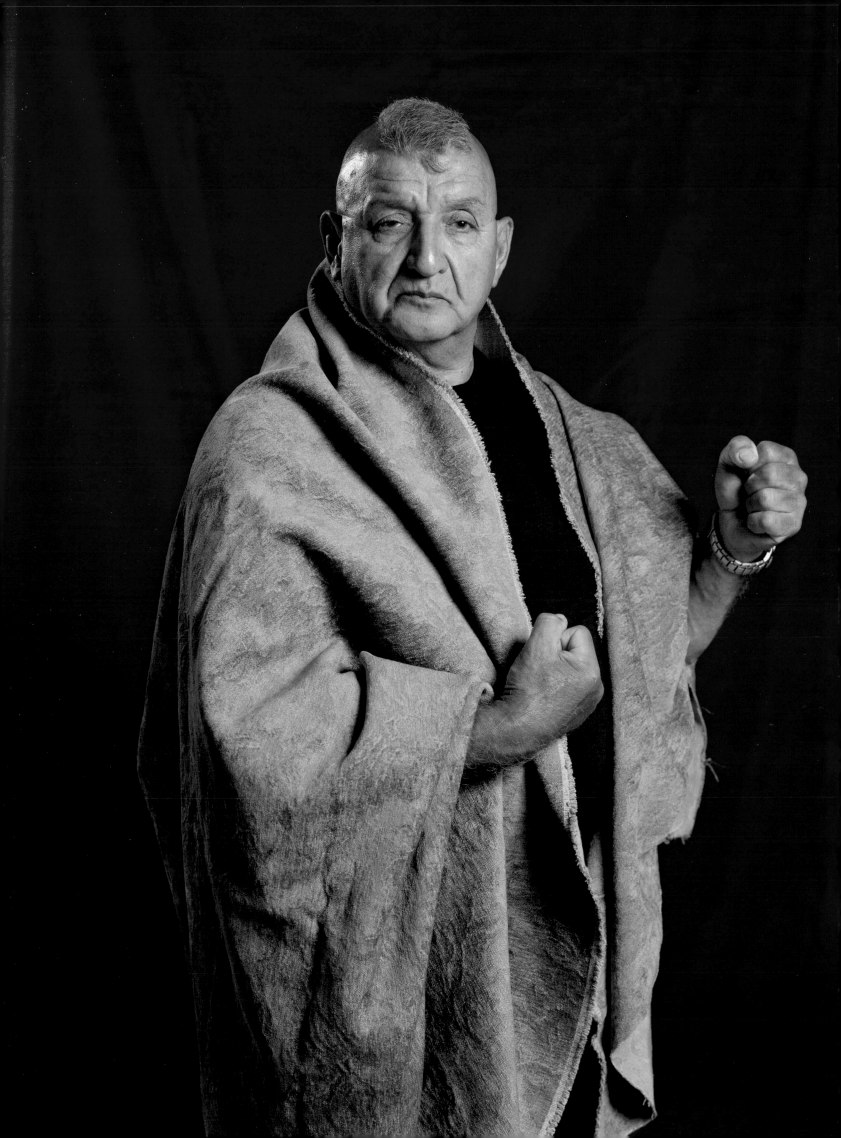

DAVE ECKERT IRAQ

Dave Eckert joined the military at eighteen against his mother's wishes. He wanted to serve the country. He was in for four years and then, after being a civilian for a year, he reenlisted. Dave Eckert loves the military, thinks it's a great life. He'd heard war stories all his life so he felt prepared. When he was in Iraq he reconnected with his religion, wanted to find the Garden of Eden but never did.

I found it hard to be a civilian. I was expected to do things on my own. Was expected to make my dinner, make my lunch, get up, do laundry, all without being told. That was kind of hard. When I joined the Guard, I'd go weekends and a couple weeks a year. That was fun but the army structure I got was only two weeks, sometimes three weeks a year. Now that I have a job—I drive a truck—I'm expected to make all the decisions. I don't have a problem doing that but sometimes you just miss the get up and have someone else tell you what to do today. Just not make any decisions.

Four of my guys died, a few feet away from me. I guess I was angry about leaving Iraq and that we didn't finish the job that our company went over to do. At least I didn't think so. And now, over the last seven or so months, it's thinking about the guys that went back that's difficult to deal with, that if someone gets hurt or killed, it's hard. It's a tough line with religion because I know nobody dies before it's their time. When it's your time it doesn't matter if you're in Iraq or here in the States, it's time for you to go. But again it's the soldier in me that thinks I can help—I need to help. If God takes someone I served with the first time, even though I understand the religion, it's still extremely difficult. Could I have done something? Even though I know I couldn't have.

And I still have issues, a lot. I guess I was angry for some of the injuries that some people that I know took. Thank goodness we weren't spit on like the last generation of soldiers. Maybe it's not so much the American people but maybe it's the way we are portrayed in the news. I've got a lot of issues with that. I get angry. I was just out with a girlfriend and I got angry at some kid in a bar. We were just having a good time and he was just a real young kid, never been in the service. But it was more my girlfriend. I accidentally hit her and I don't even remember that. And that was the end of that. All the good I did in Iraq, I didn't want to be remembered for what happened at a bar. I didn't want to be a disgrace to the rest of the guys that were over there so I decided to go and get some help.

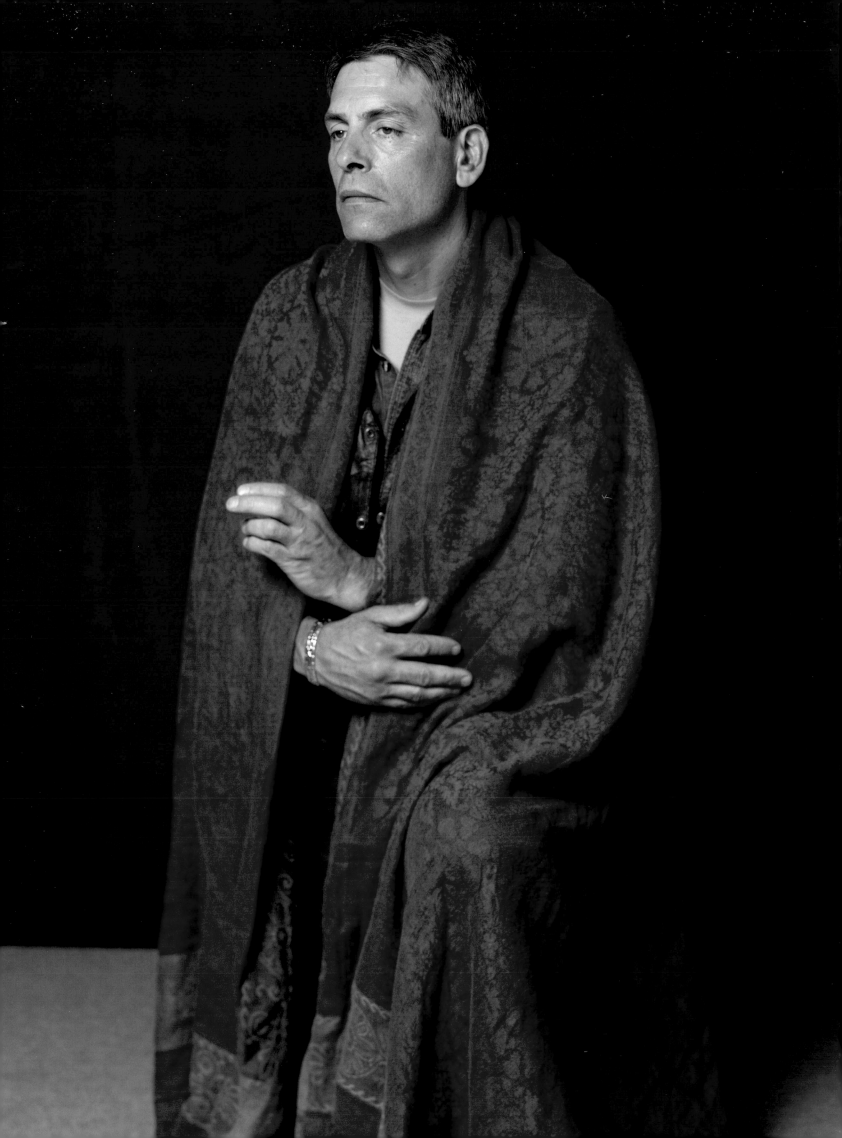

PERRY MELVIN VIETNAM

Perry Melvin served in a Combined Action Program (CAP) unit in Vietnam where he and a dozen other Marines lived in a village with local families. He worked with midwives and shamans providing health care for both Marines and villagers. They learned the language, helped with civil projects, and protected the village. It was gratifying work but it also involved witnessing many deaths that he had no way of mourning. Without recognizing it, he came home to live his life at a distance for thirty years until he was fired from his job as director of a health care organization. Then, as he says, "all hell broke loose."

For three weeks I was there running that organization, knowing that I had been terminated and still functioning at the best level I could. I couldn't believe I stayed totally controlled during that whole period. A lot of the time it was almost like having an out-of-body experience. I didn't feel connected. The day I left, I came in early before anybody was there, packed up my stuff, left my keys, left the place. When I got home, that's really when it hit. I couldn't sit down, you know, I just paced. All of a sudden there was the anger. All of a sudden key people at work who were instrumental in pushing for my being dismissed . . . all of a sudden, I wanted to kill them. Just this rage, incredible rage. I kept telling my wife, "I just hope these people don't come to Burlington, because God help me, I don't think I could stop myself." Within two weeks I couldn't function. I tried interviewing for jobs but my demeanor was off. I ended up working a temp job and I even worked on the line for Pepsi. That was pretty much the only job available so I did it.

I saw so many deaths, not only our Marines, but local people killed. A mine went off and I remember going down there and putting pieces of a mother and daughter together and then packaging that up in a bag and carrying it up to the village. I can remember one incident when an older man had been executed and I just sat there staring at him, looking at him like objectively and thinking, "Oh geez, his eyes are sunken in . . ." and all this other stuff. I had no emotions whatsoever.

I did a very good job of burying all these emotions, but things leaked out. There were periods of anger and rage that would come out. I would withdraw from situations, which was my way of dealing it. I didn't physically act out, I withdrew. So when there were situations with my children, my wife would have to deal with them and I would basically go into myself and all but disappear. I would end up sitting in another room, some place else, and separate from family, separate from other people. Wanting to be left alone, mentally just disengaging.

I look back and think that had the VA been doing what they're doing now for returning veterans, had they been doing that for us, I might have been dealing with this at a very early point. I might have been a success and not have had this episode later in my life, in my fifties.

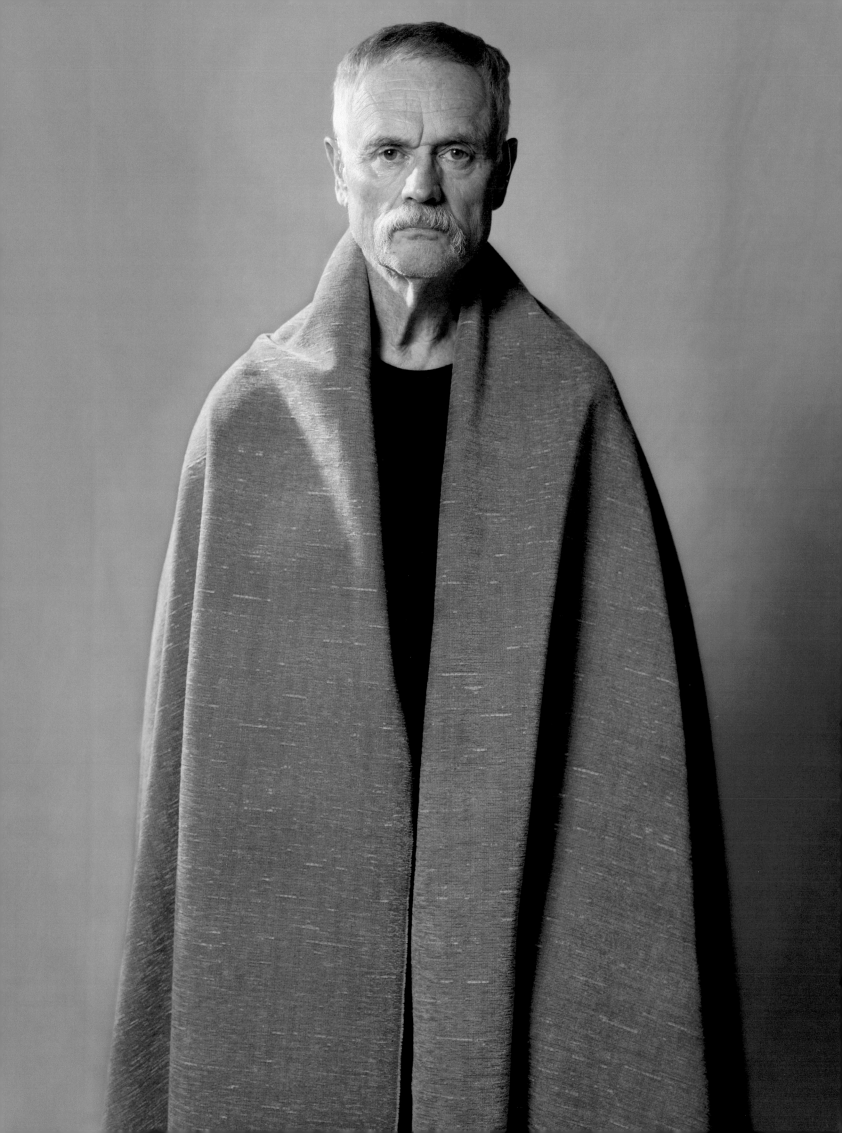

CHRIS HINSHAW IRAQ

Chris Hinshaw has seen a lot of death—his foster parents, his grandparents, friends in the Chicago neighborhood where he grew up, and buddies in Iraq. He describes himself as a guy who keeps to himself, safer to stay detached. He was a driver in Iraq, a very dangerous job. Chris loves the structure of the military, but now he suffers from TBI, so his life plan to stay in the service is completely derailed. Chris takes one medication for depression and one to ward off nightmares. He has to be careful to keep in a straight line when he walks. Still he's convinced he's one of the lucky ones.

I got hit by an IED, a small one. I took a rest for a couple hours and then the next day I went back out. I was a little woozy. I wasn't on my game so I didn't see a bigger IED and it blew up. That's when I got hurt. It knocked me out cold. I woke up in the hospital. The other two guys beside me, one died and the other one was okay. I didn't see the IED and he died. He was a good guy. I mean he grew up poor, you know. He always wanted to be in the military, and he had mouths to feed so he just wanted to do his job. I mean he had a wife, he had three kids, with one on the way, so he had four.

He had a military funeral and I went. I was in the hospital in Germany. I just thought I should go down there and pay respects. So I left Germany, you know, against doctor's advice. I just went there and stayed there for like a couple days. I stood in the background. He was from Arkansas. I found out what town he lived in, when his funeral was, and I just went down there and saw the funeral. I was like standing in the background and I was watching them. They did the whole salute thing. I saw his wife and I saw the kids. Little kids. I mean I saw two boys, a girl. I don't know what she was pregnant with. I think it was a girl so I mean one was like four years old, one was like three, another one was like one. And I saw her and I saw his casket and they were doing the whole military thing. Then she contacted me on MySpace. She said she saw me and she just wished I'd come up. She don't hold no ill will toward me. But four kids, I mean what's she going to do? Four kids by herself.

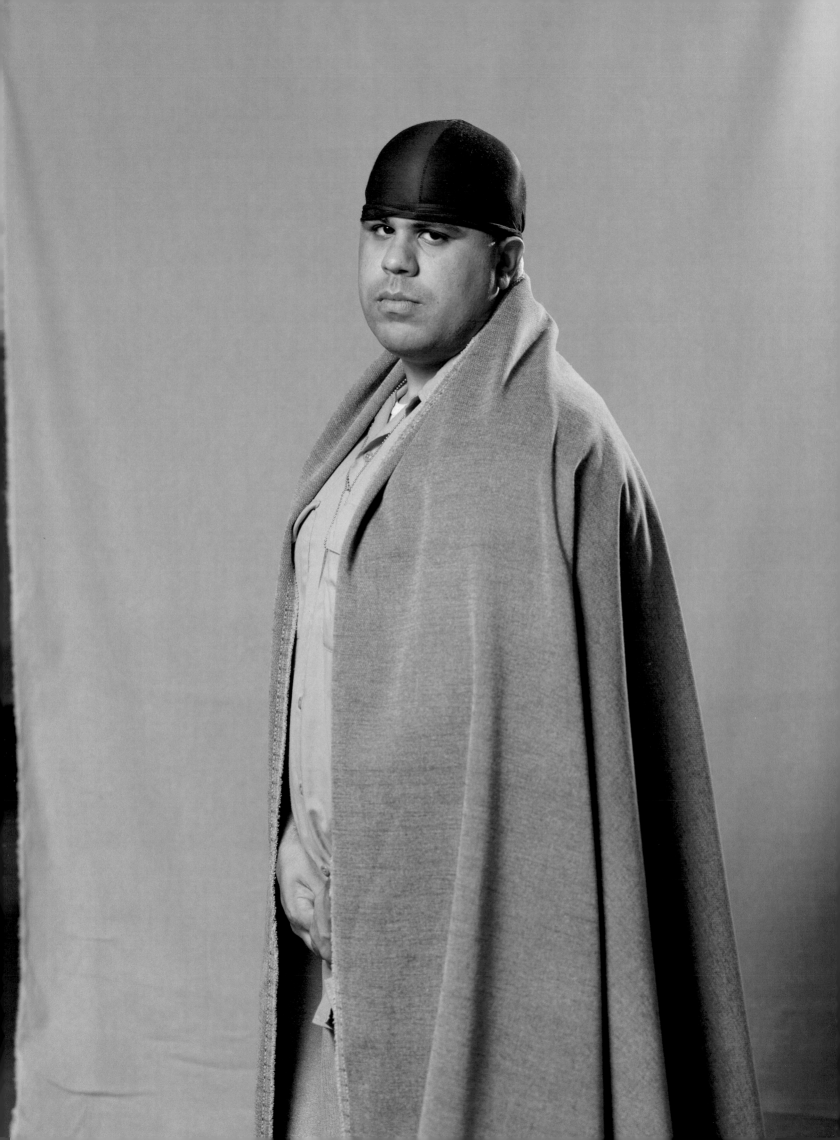

JORDAN PAQUETTE IRAQ

Jordan Paquette joined the National Guard in 2004 when he was twenty years old. He was a driver of a Humvee in Iraq and went on house raids. At the time of the photograph, Jordan had been home for three years. He was married with a baby, unemployed, and in fear of being sent back. He thought another deployment would destroy him mentally.

I had to kill people. Sometimes I wonder if killing them was the right thing to do or the wrong thing to do, but you can't help what's already done. We always killed because it was either them or us. We'd go into a village and do a house raid and come into a room and all of a sudden someone's sitting there with an AK-47, waiting for you. It's like someone going into your house and you're sitting in your favorite chair, waiting. Same idea. We'd go into their house, and they're sitting in their favorite chair, waiting. And that was it. They went to stand up real quick and we'd put two in their chest. Without even hesitation. It was never easy. No matter how much you train for it and do it over and over again. Shooting at a paper target and shooting at someone's flesh is completely different, I don't care what anyone says.

You know that that could have been someone's father, someone's brother, someone's son. But now coming back I tell myself, "I am someone's son. I am someone's father. I am someone's brother." I forgive myself. Yeah, I do. It's taken me a while to do it. You're only going to beat yourself up and how can I change it? It's not like I can go back and do CPR on someone I shot in the chest three times.

If I'm in the mall with my wife, I always carry a side arm. I always carry a pistol on my back. Always. Because you don't know. But I'm much more appreciative of life now. It's just small things now . . . I would lay on the grass for hours. Because there's no grass. None, it's just sand. It's just small things now that I appreciate—grass, fresh air, water. All things you don't see while you're there. I was a year and a half away from these things you take for granted every day. I always tell people now, even if I'm going to the store and I'll be gone five minutes, that I love them. My wife, I always say, "I love you." She says, "I know." Okay, just as long as you know, because you might not be there.

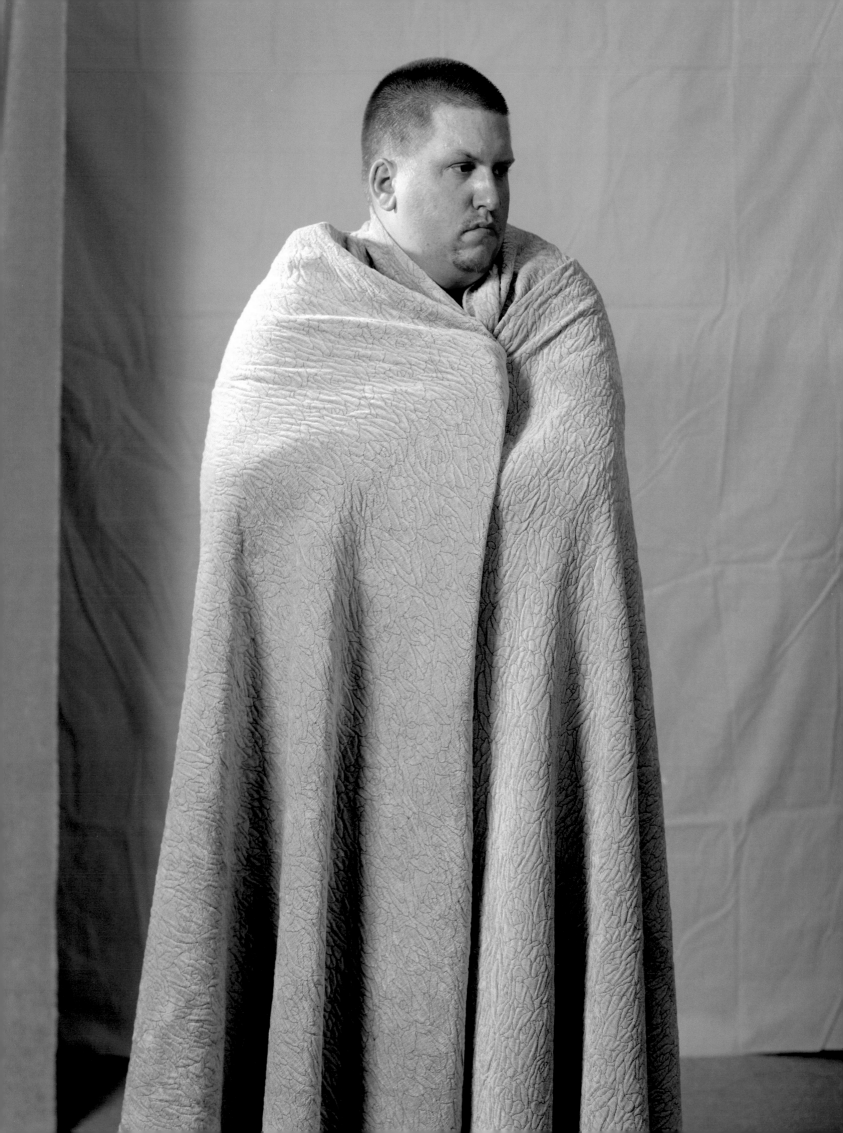

STEVEN LOPINTO IRAQ

Steve Lopinto says he was a pot-smoking rebel in high school. At eighteen with no money for college, joining the military seemed like something to do. He served as a line medic in Iraq, but he never had the opportunity to care for the wounded because everybody died. When he came home, Steve started drinking and taking drugs, a habit that got him kicked out of the military, landed him in jail, then in a VA psychiatric hospital, and finally in a facility for homeless veterans. Steve is not on medication. He says he spent a lot of years medicating himself and it didn't work, so why would he let someone else medicate him with drugs that might leave him with suicidal thoughts, kidney failure, or erectile dysfunction. He doesn't want any of it. He has plans to get his life back after the court takes the GPS monitor off his ankle and he's free to go where he pleases.

One image I have is of the Iraqi father carrying his child. This guy is holding his son and like babbling and just kind of like off in the middle of nowhere. Like he was praying or something, and he had his dead son. Unless he was sleeping but it didn't look like he was sleeping. Too much blood for that. So he was carrying him down the street. It was like a movie. That's kind of what it felt like and then right after he passed, it was time to move out. But that image, it's like an ongoing thing. That scenario, the whole situation is never gone. The reason I think it stuck with me so much is because I was a medic, and so seeing a child dead made me feel helpless. It's like, I should do something but what am I gonna do? I mean you can't bring somebody back from the dead.

So I was seeing this girl, my friend I've known since kindergarten, and we went out and we were drinking and doing drugs and stuff. And we went back to her apartment and we went to bed together and I woke up and I was beating up on her. I had a nightmare. I woke up in the middle. I woke up because she had punched me in the jaw. I guess I had punched her in the face a couple of times and I don't know exactly what I was doing but I know I broke a couple of teeth. And so when I realized what happened, I turned myself in to the police and I told them, "Yeah, I just beat her up. I think I tried to kill her. I don't know really what happened." So they sent me to jail. I did something pretty terrible. I did something that's totally against my morals and I never ever would have thought of doing something like that. And so it's like, what kind of person are you? Jesus. What the fuck? I was blaming myself and then it just got me down lower and just kind of like, "Oh, I'm a piece of shit, might as well just keep doing drugs." And then, "I'm a piece of shit, I'm probably never going to have another relationship. Nobody's ever going to trust me again and everybody's going to think of me as some woman-beating drug addict." I am my harshest critic and nobody else can tell me I'm a piece of shit more than I can tell myself I'm a piece of shit. And I do.

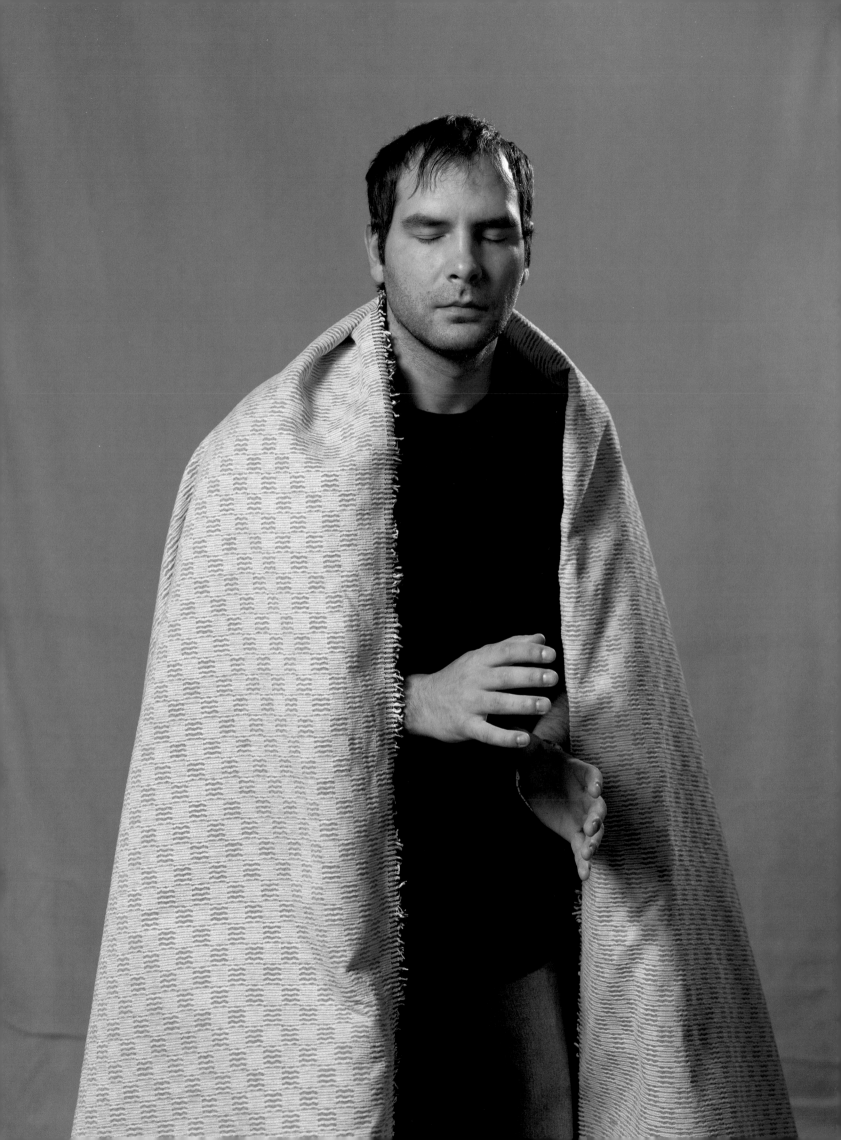

ANDREW COTREL IRAQ

Andrew Cotrel was part of the invasion force that toppled Saddam Hussein's government. While waiting in Kuwait, his platoon slept in a warehouse filled with thousands of coffins stored for the expected U.S. dead. He didn't sleep well but he says that if that was all that he experienced in Iraq, he would be okay now. Andrew is haunted by images of countless dead Iraqi civilians and American soldiers. He agreed to be photographed, but declined an interview because of how "depressed, hopeless, and anxious" he was feeling. He just couldn't talk about it.

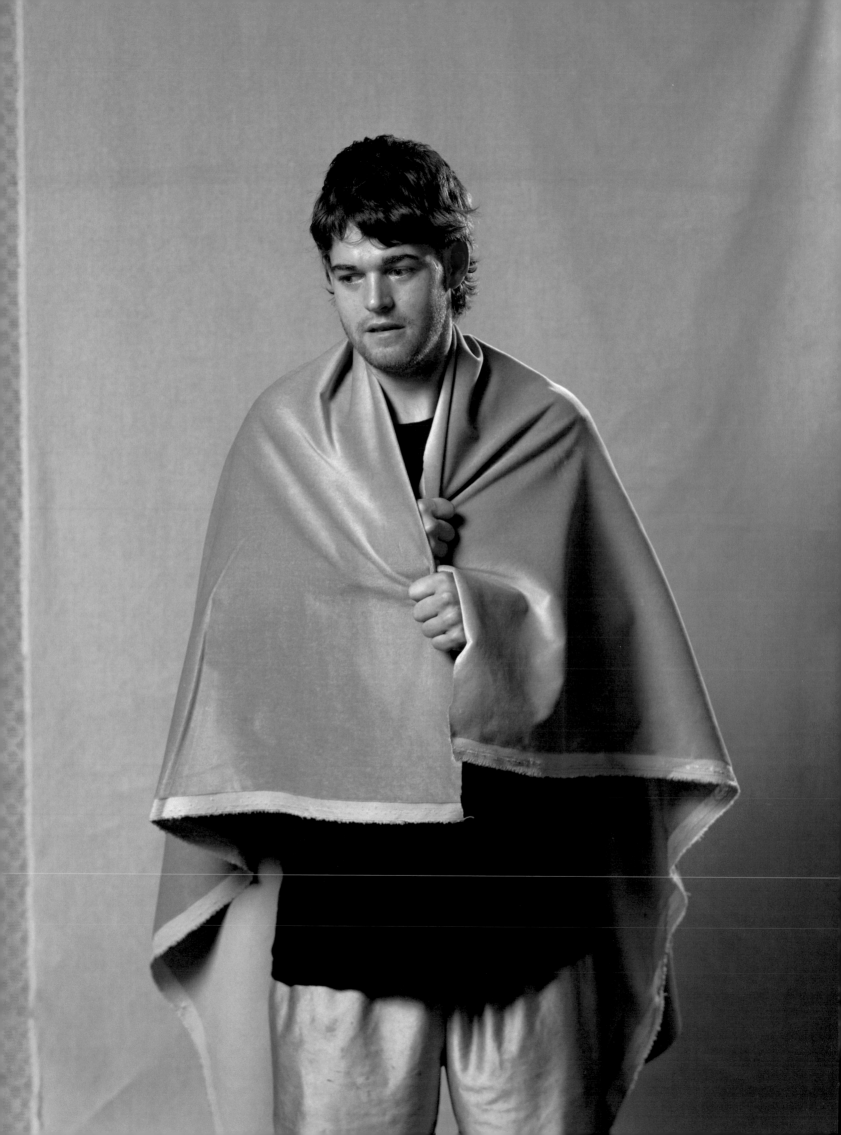

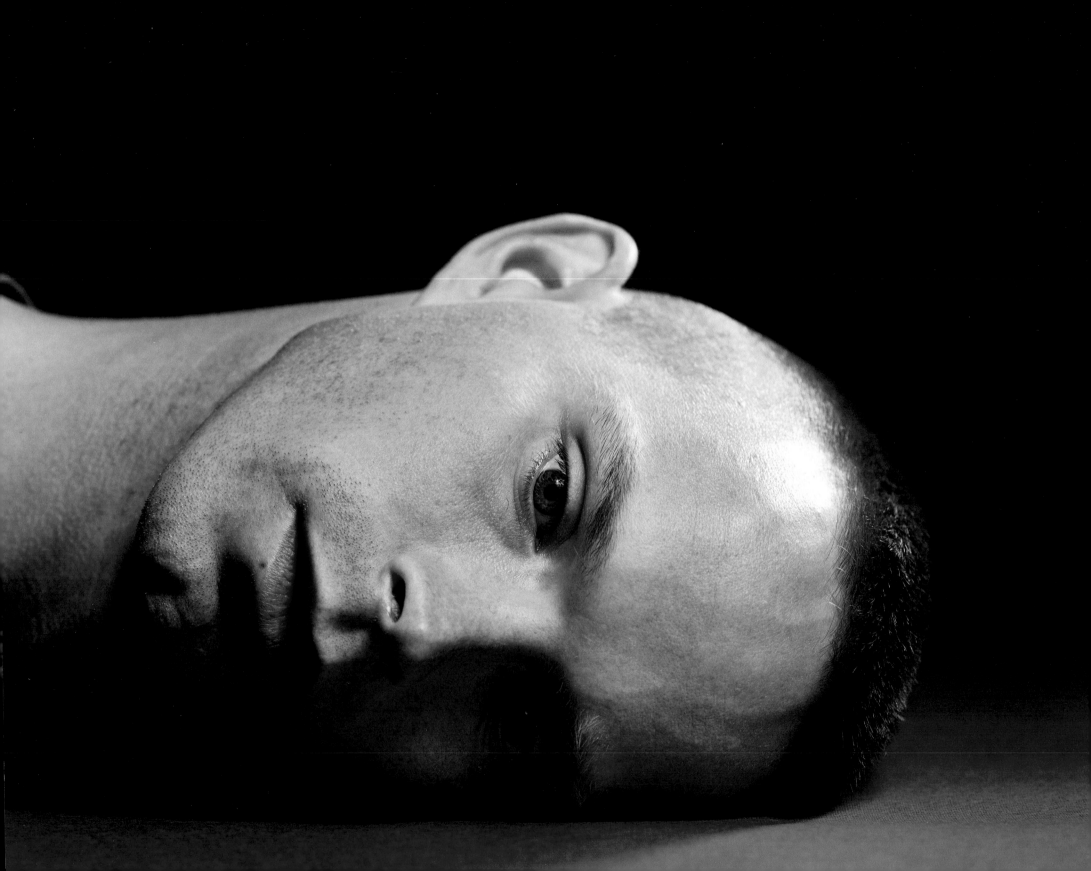

SOLDIER: CLAXTON 120 DAYS IN AFGHANISTAN

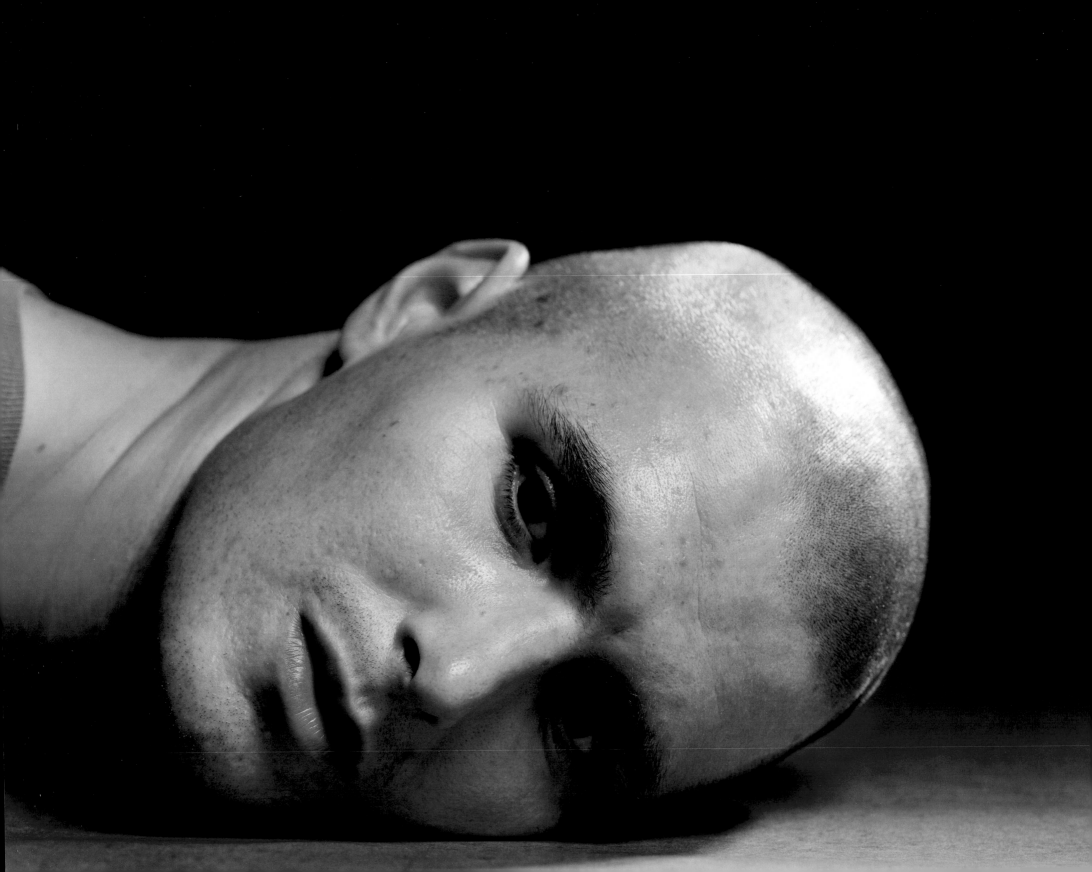

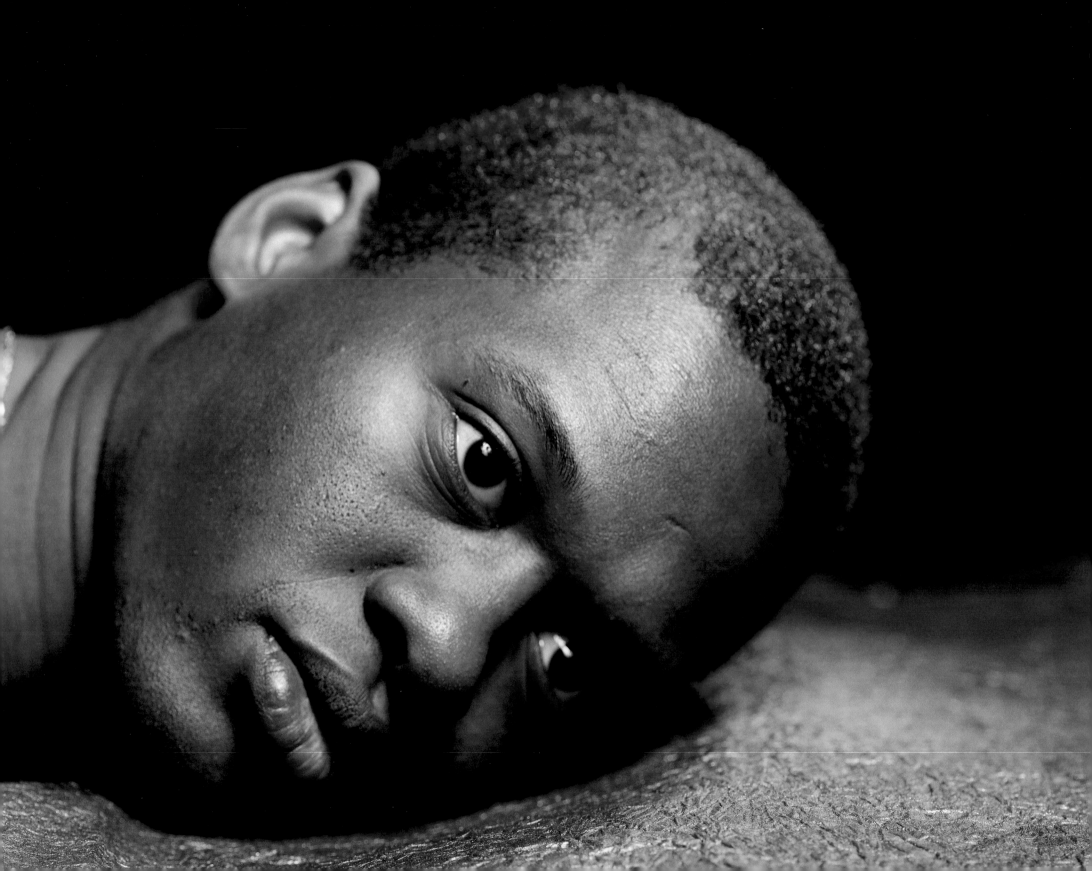

SOLDIER: KITCHEN 366 DAYS IN IRAQ

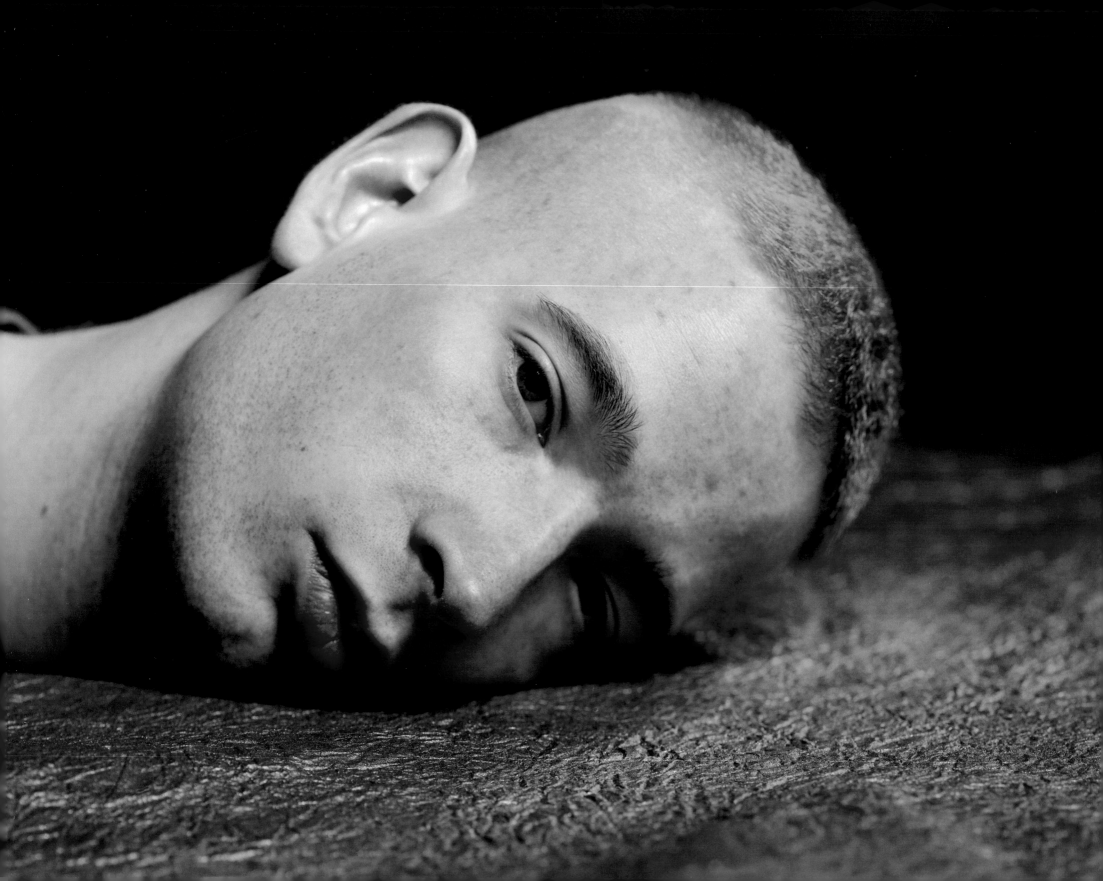

SOLDIER: CONKLIN 272 DAYS IN IRAQ

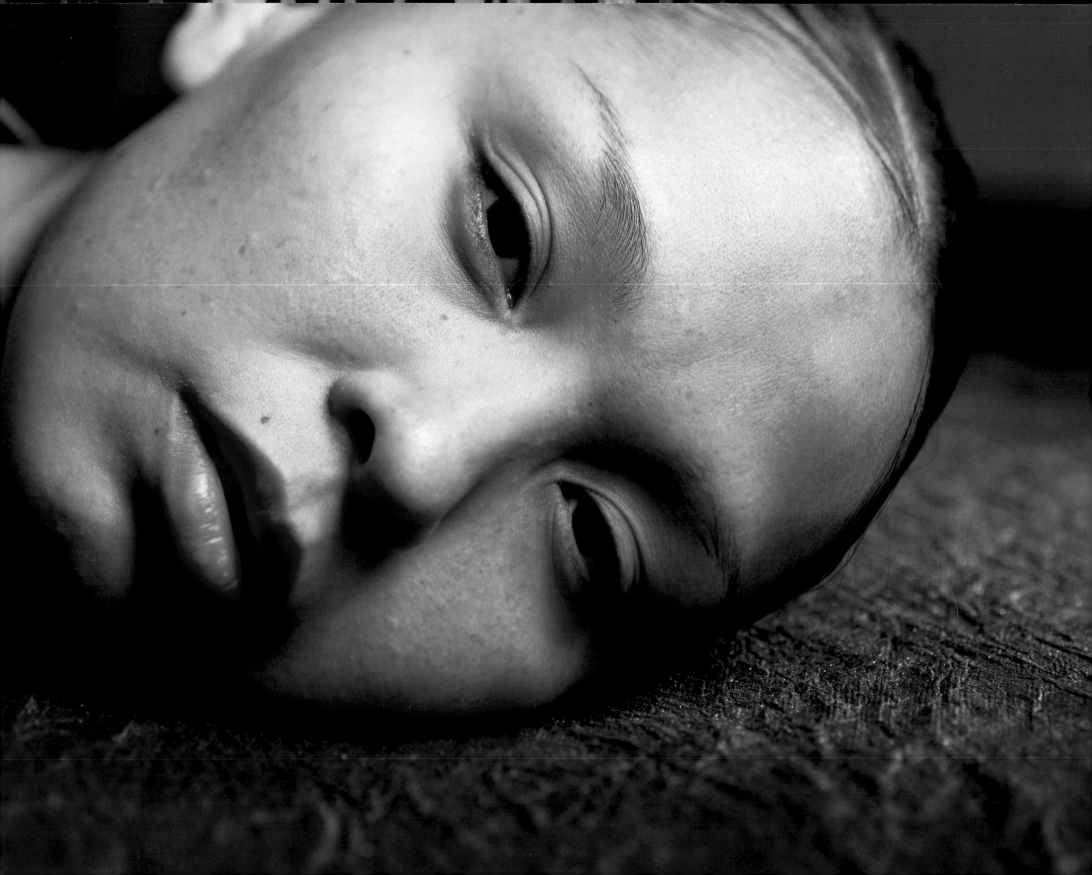

SOLDIER: L. JEFFERSON LENGTH OF SERVICE UNDISCLOSED

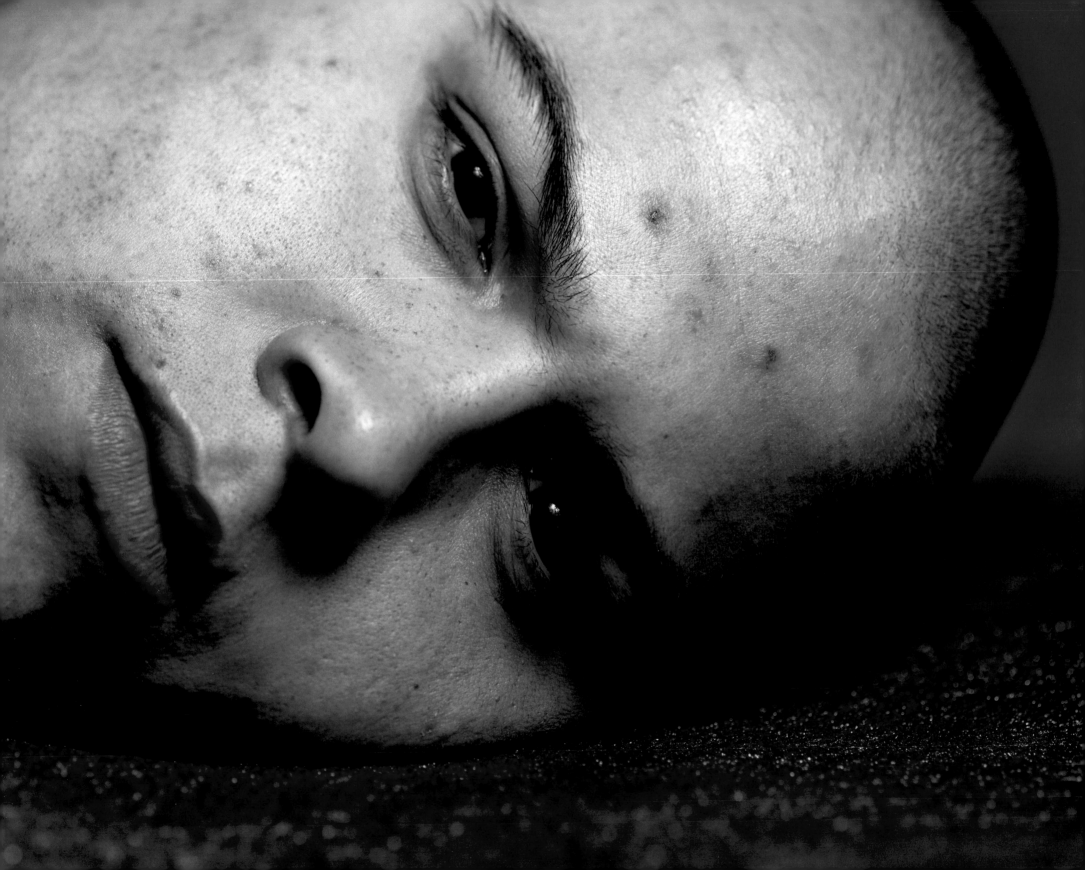

SOLDIER: WHITE LENGTH OF SERVICE UNDISCLOSED

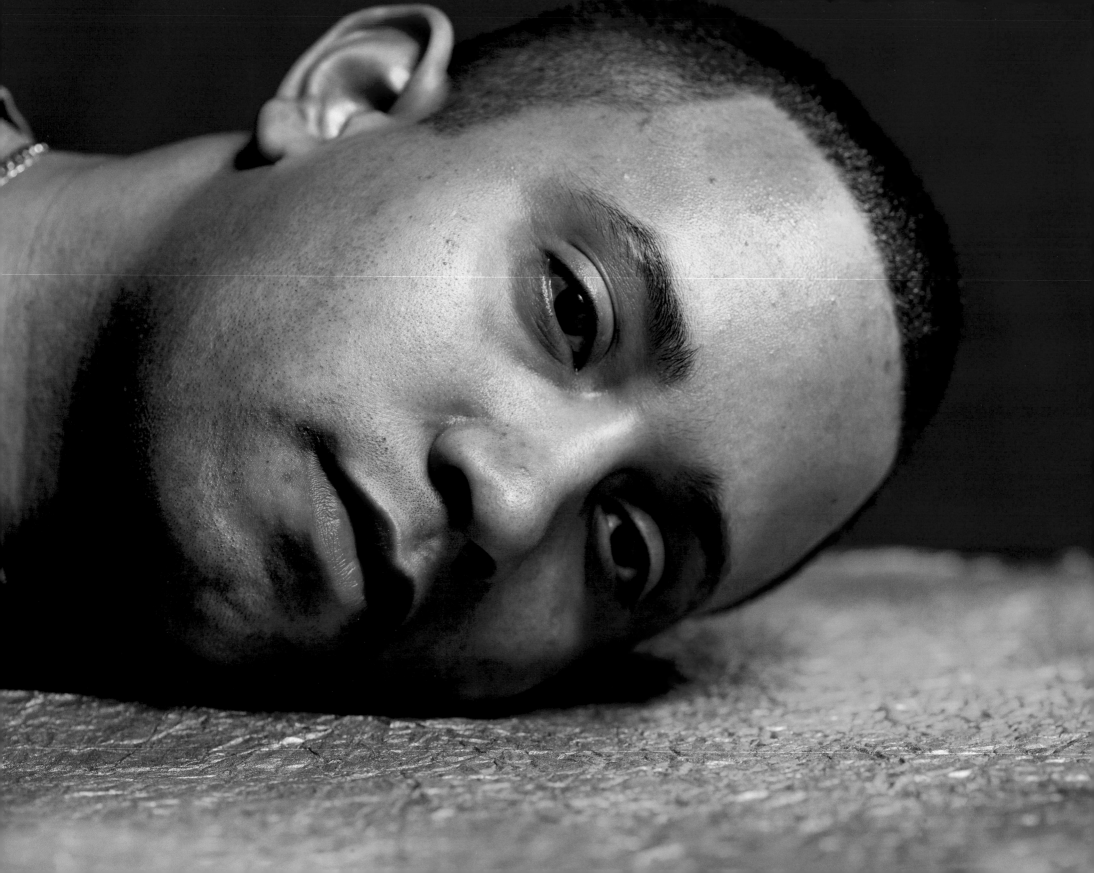

SOLDIER: DIAZ LENGTH OF SERVICE UNDISCLOSED

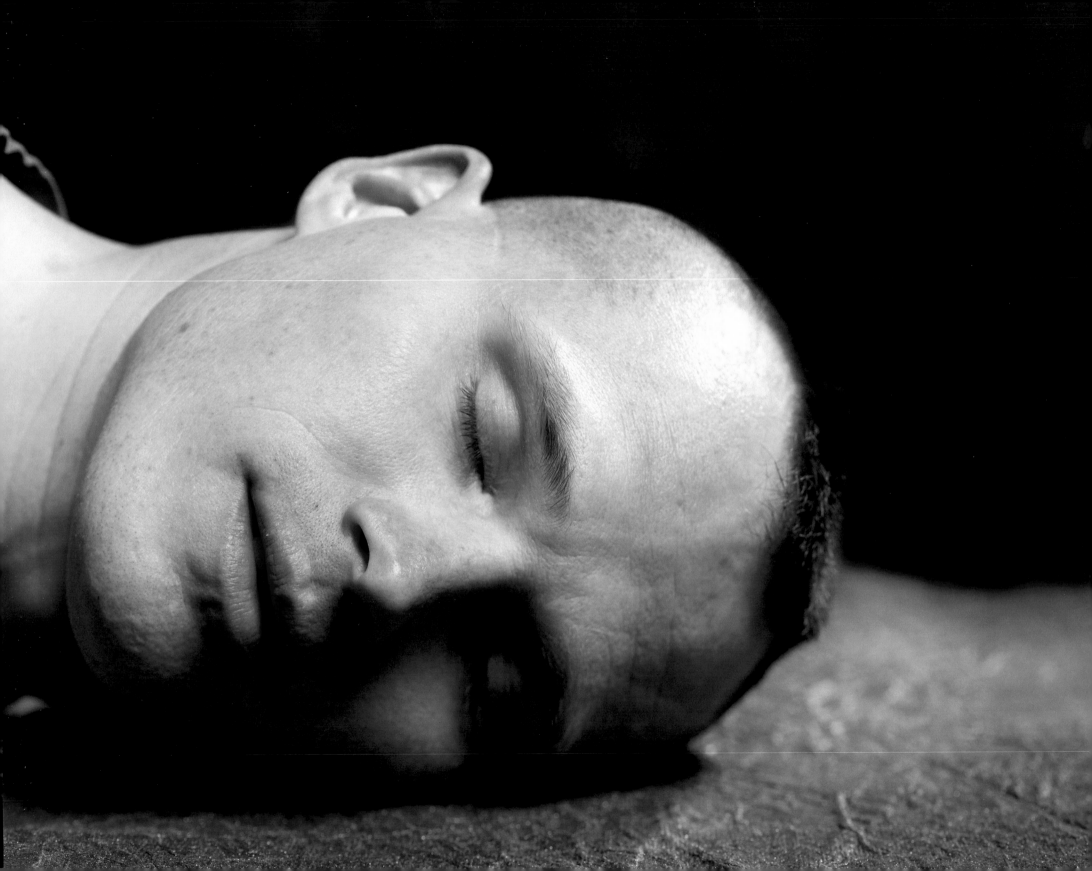

SOLDIER: PRY 210 DAYS IN AFGHANISTAN

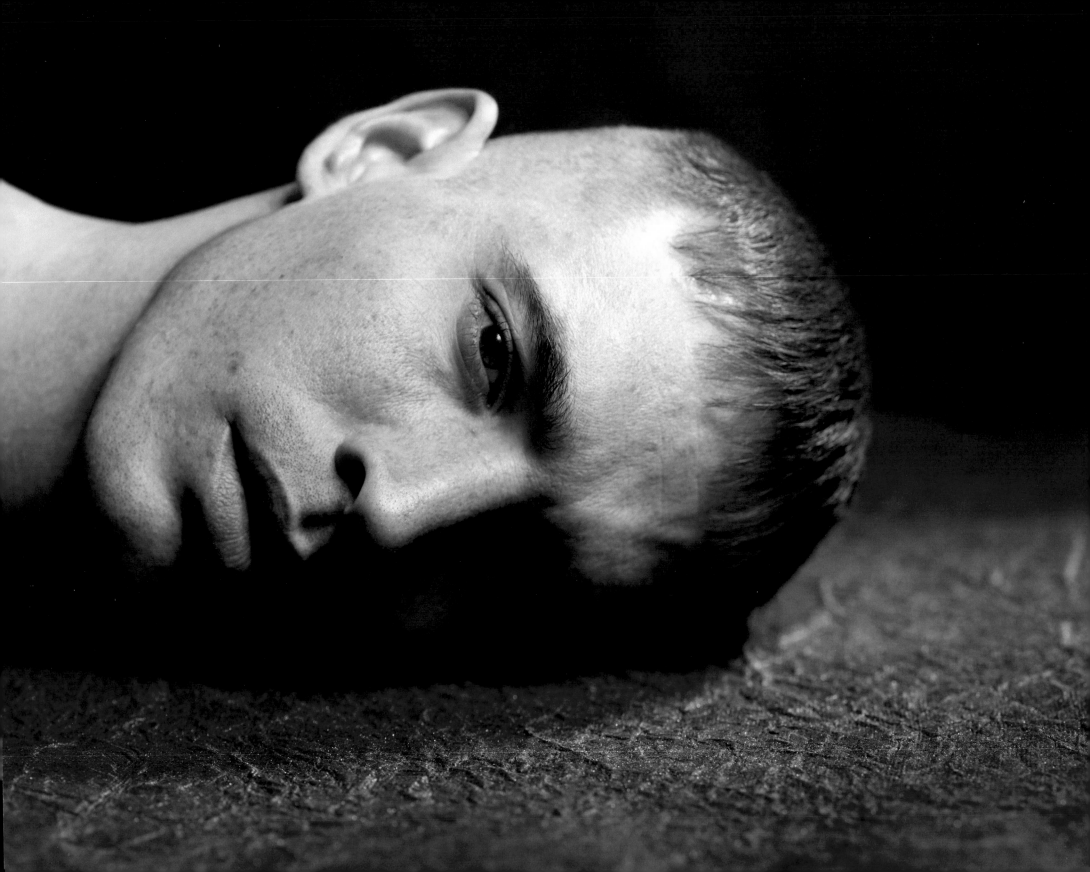

SOLDIER: CRUMM 294 DAYS IN AFGHANISTAN

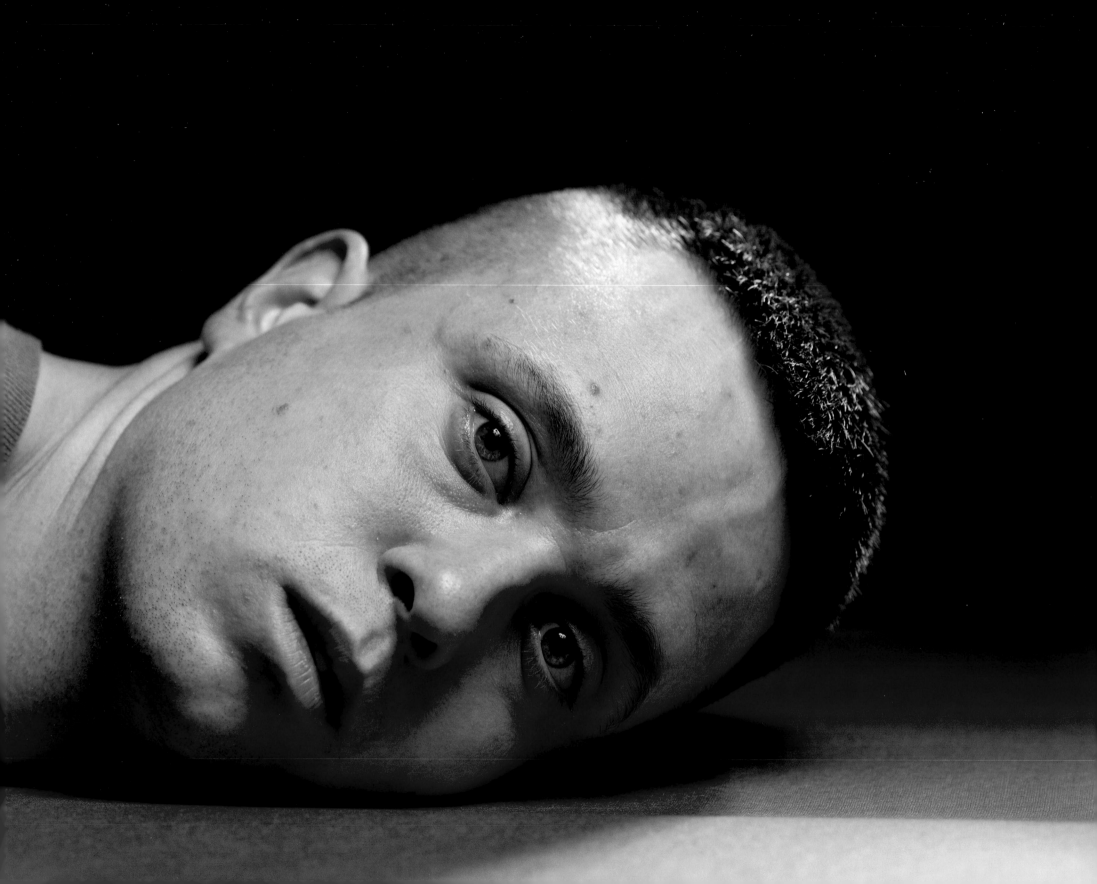

SOLDIER: BRUNO 355 DAYS IN IRAQ

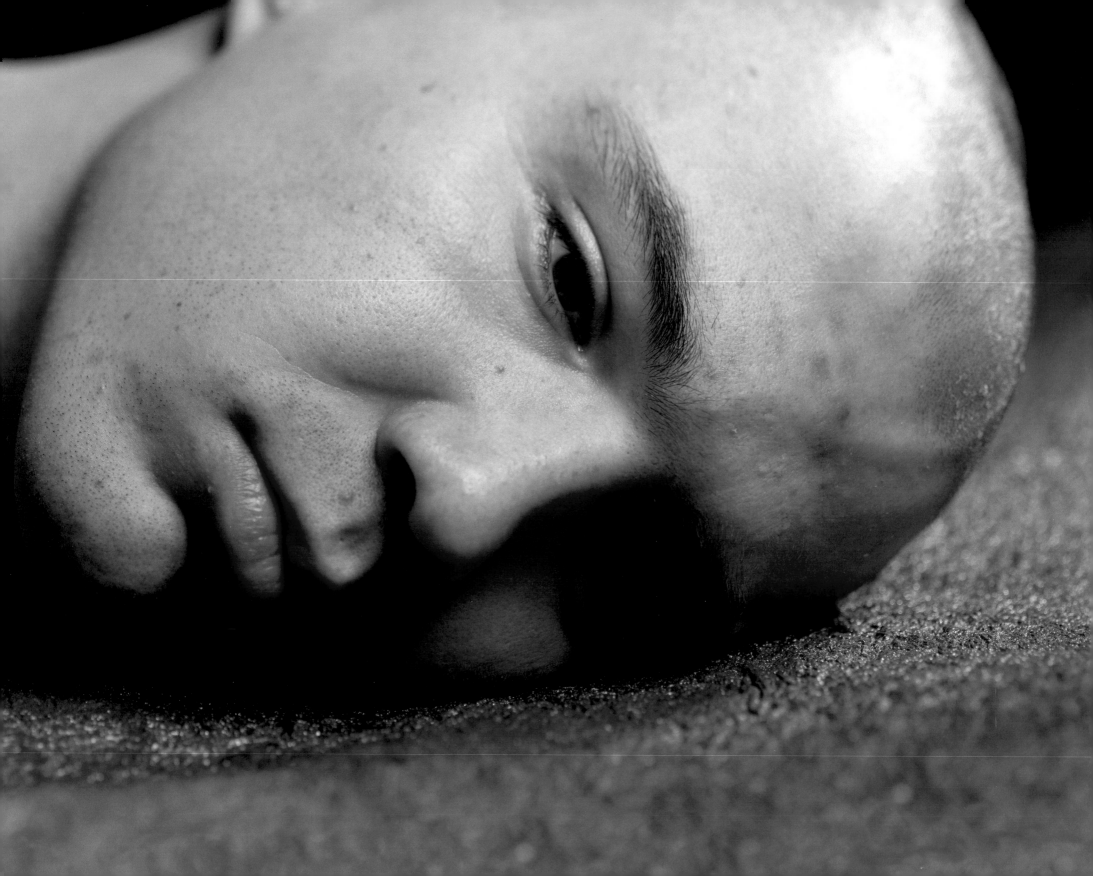

SOLDIER: DAWES 303 DAYS IN AFGHANISTAN

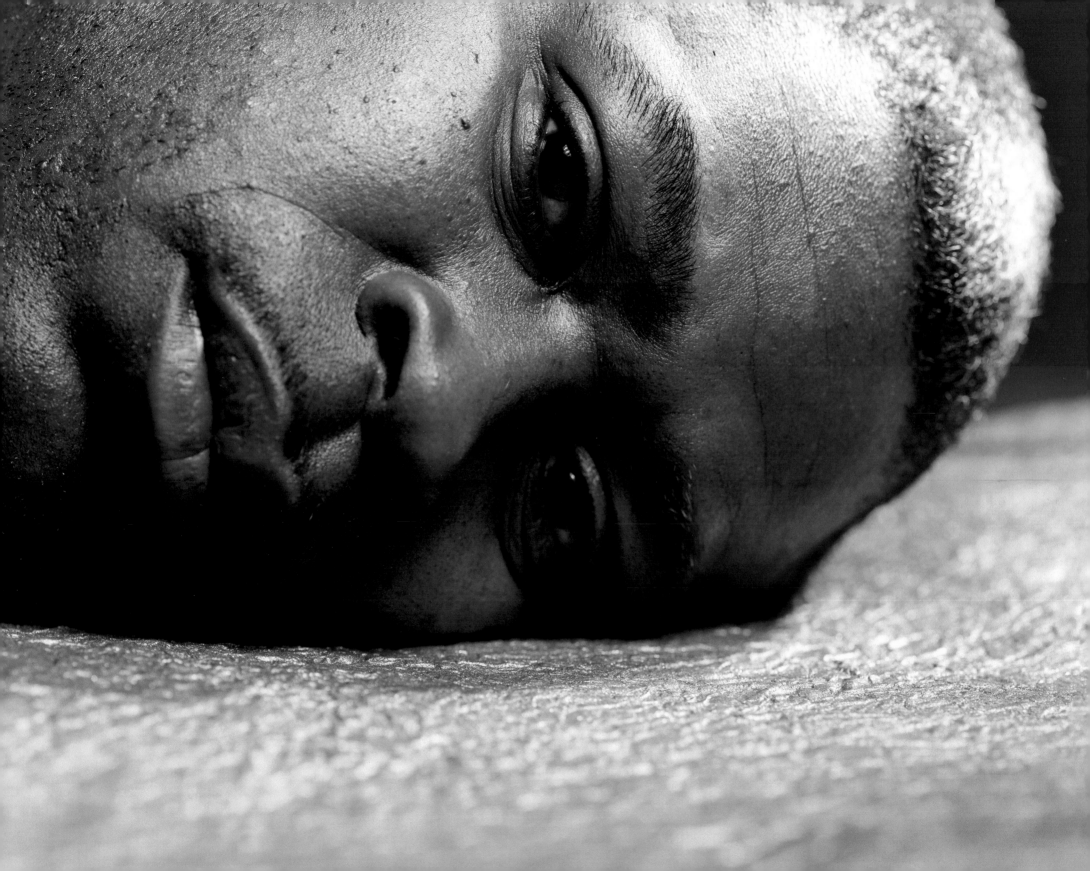

SOLDIER: WILLIAMS 396 DAYS IN IRAQ

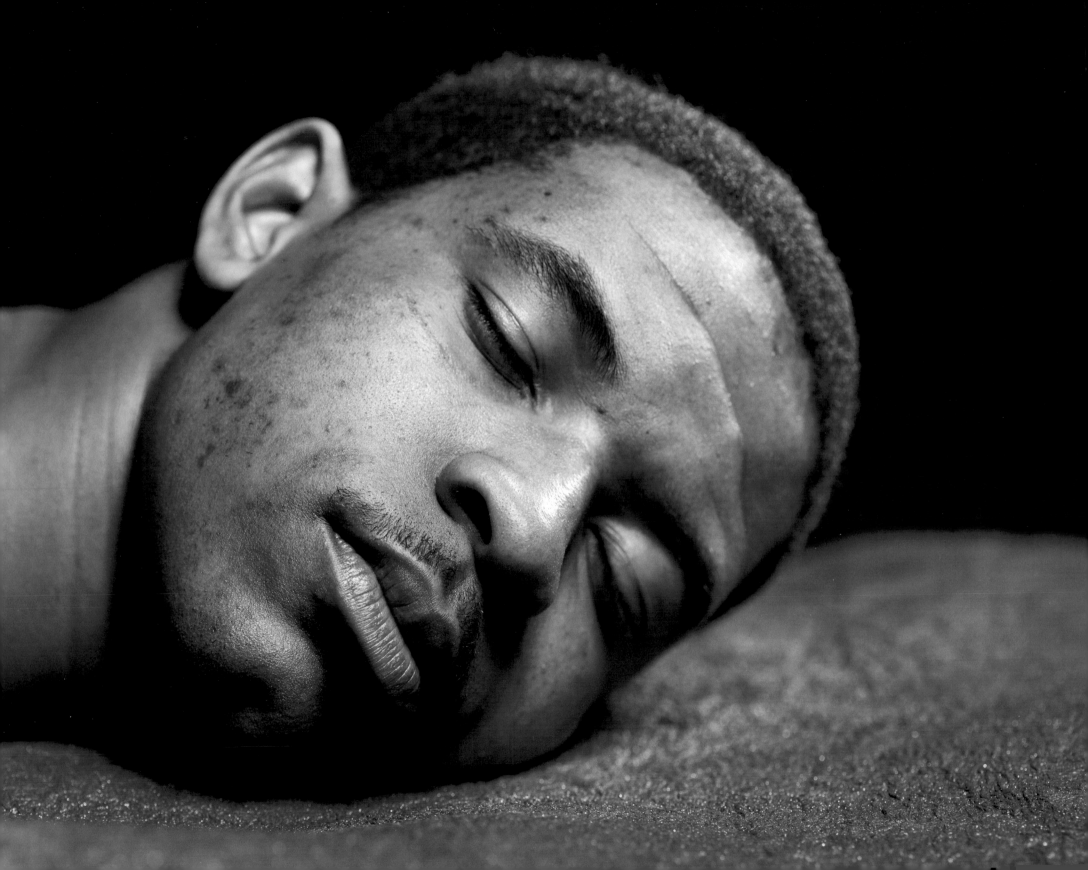

SOLDIER: NEAL 427 DAYS IN IRAQ

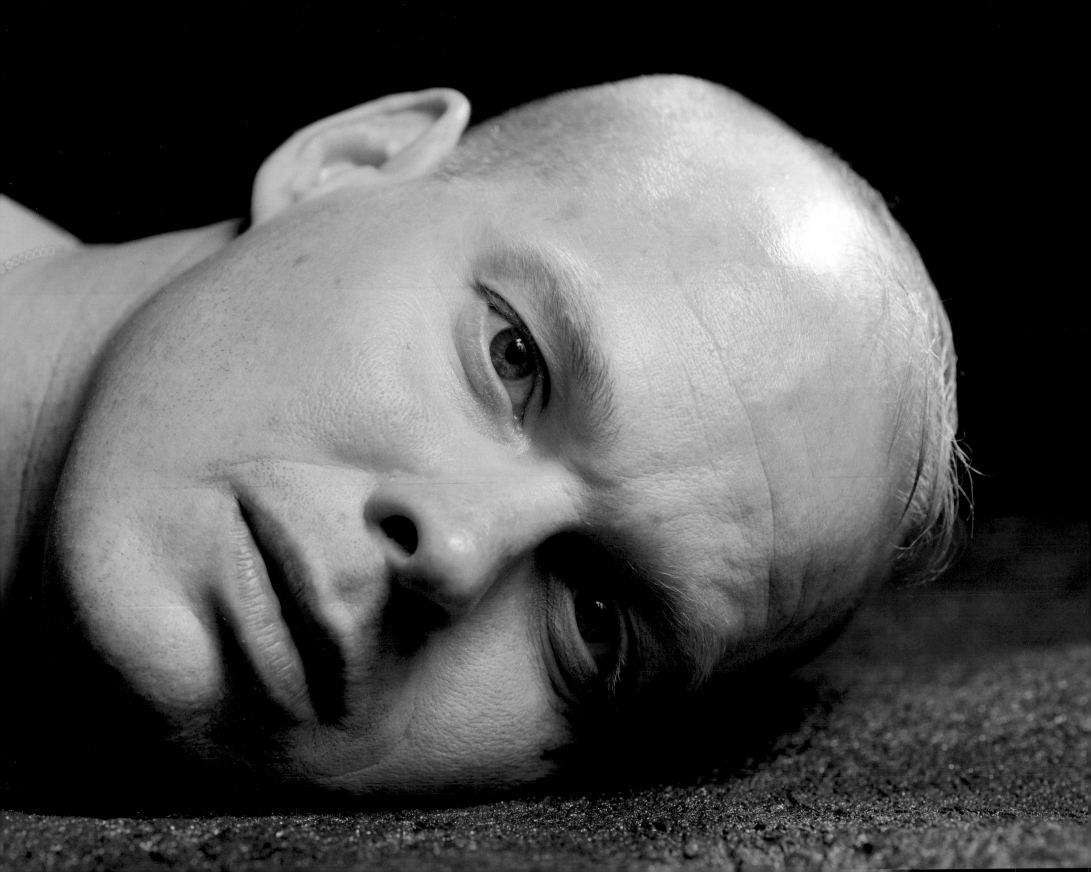

SOLDIER: BOSIAKI 364 DAYS IN IRAQ

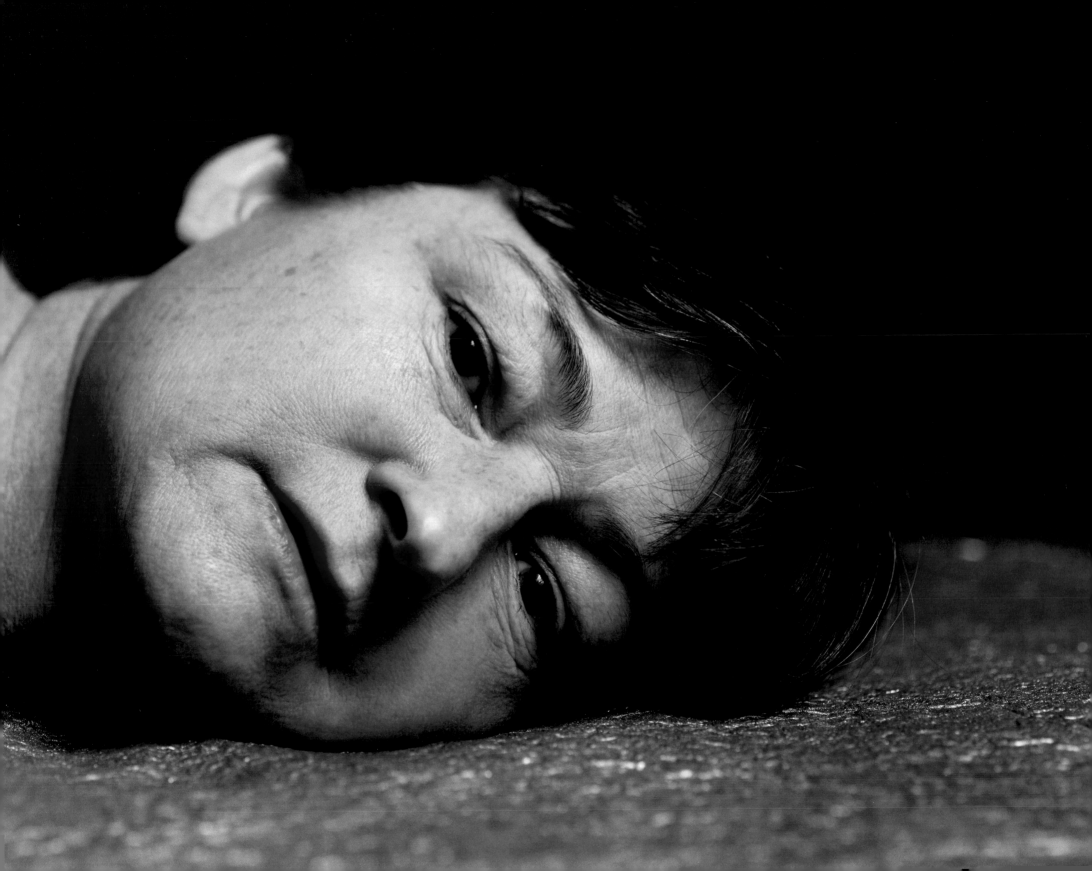

SOLDIER: OPEKA LENGTH OF SERVICE UNDISCLOSED

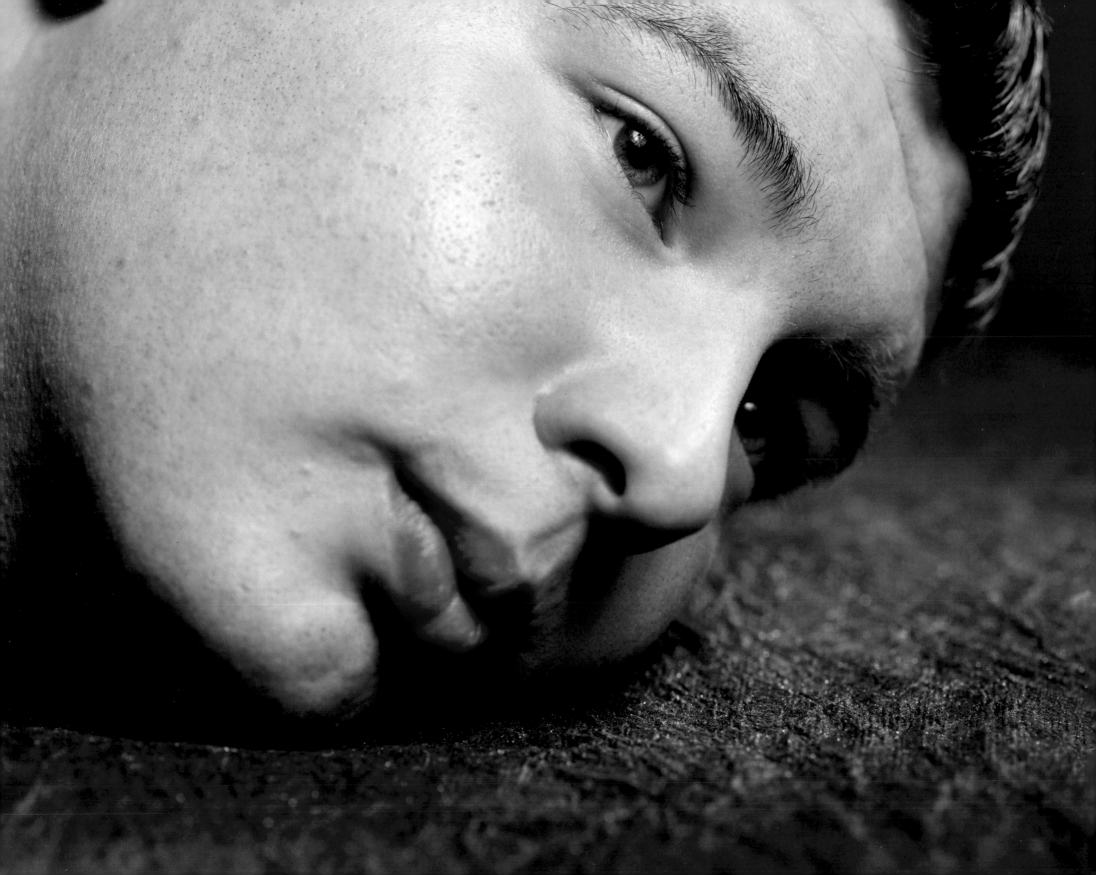

SOLDIER: KIMBALL 287 DAYS IN AFGHANISTAN

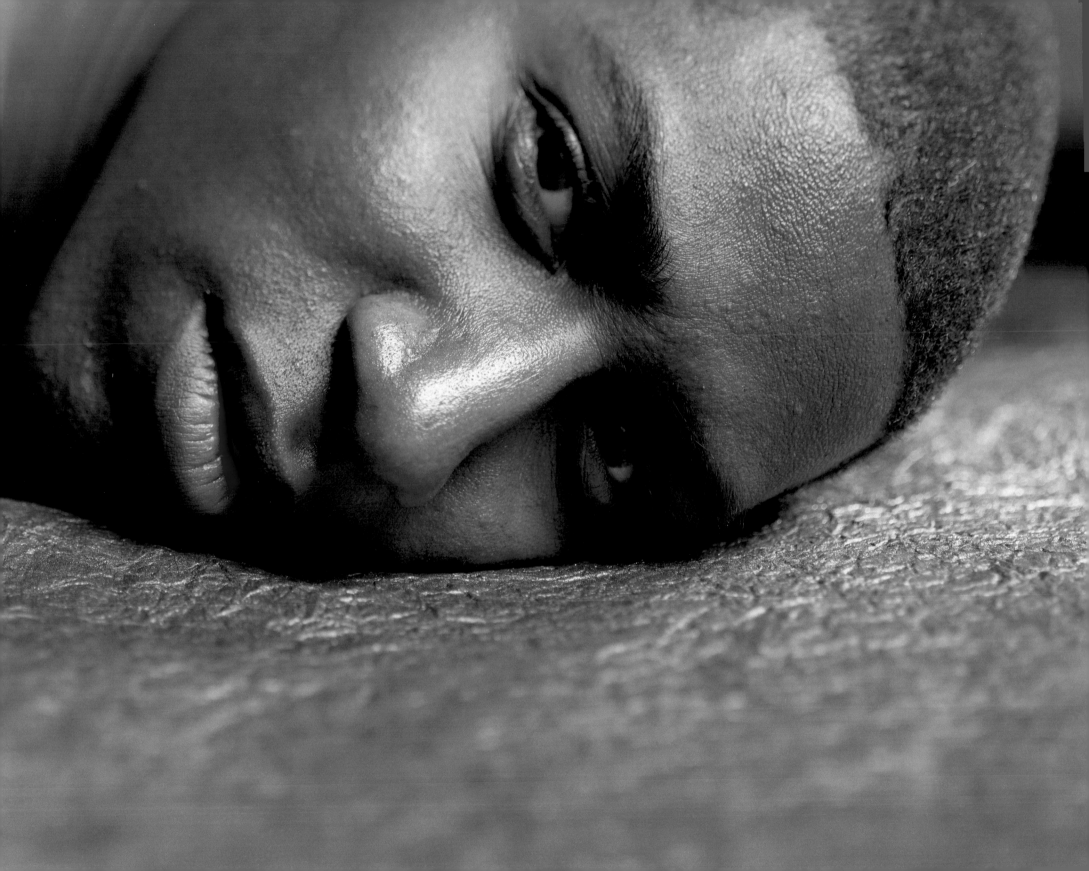

SOLDIER: JEFFERSON LENGTH OF SERVICE UNDISCLOSED

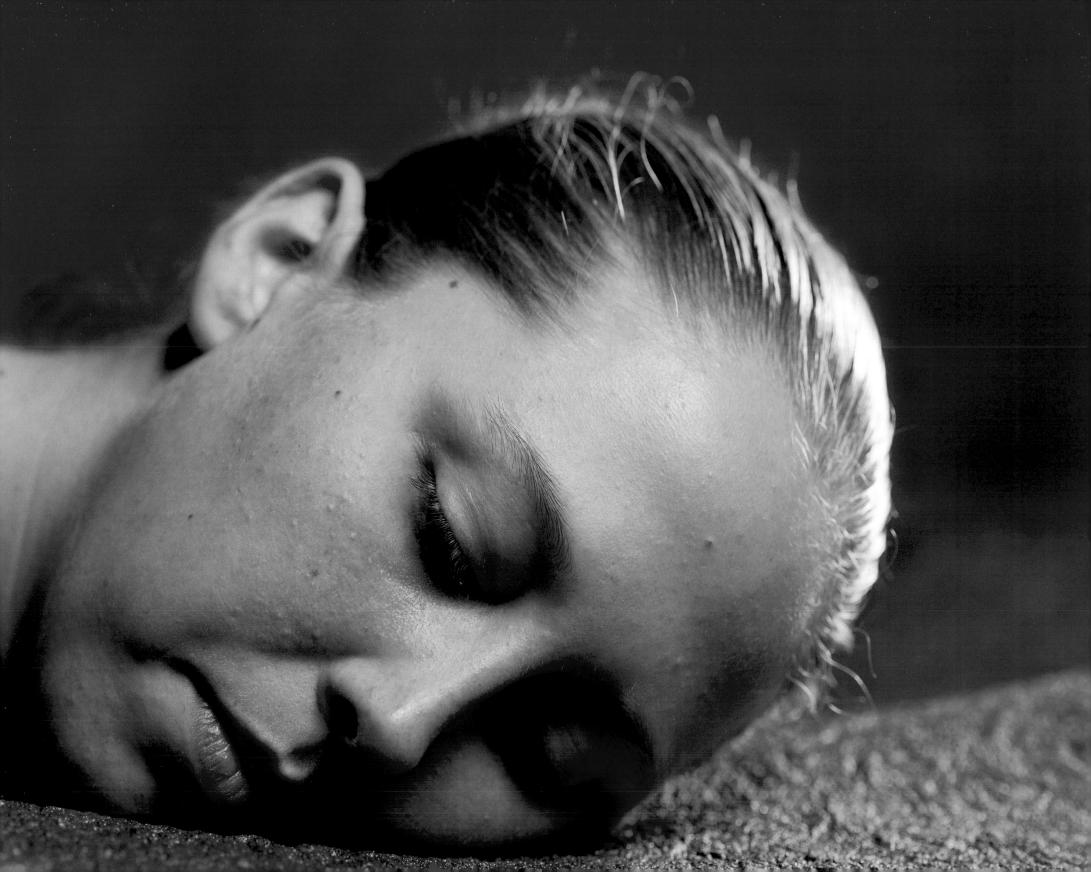

SOLDIER: MORRIS 112 DAYS IN IRAQ

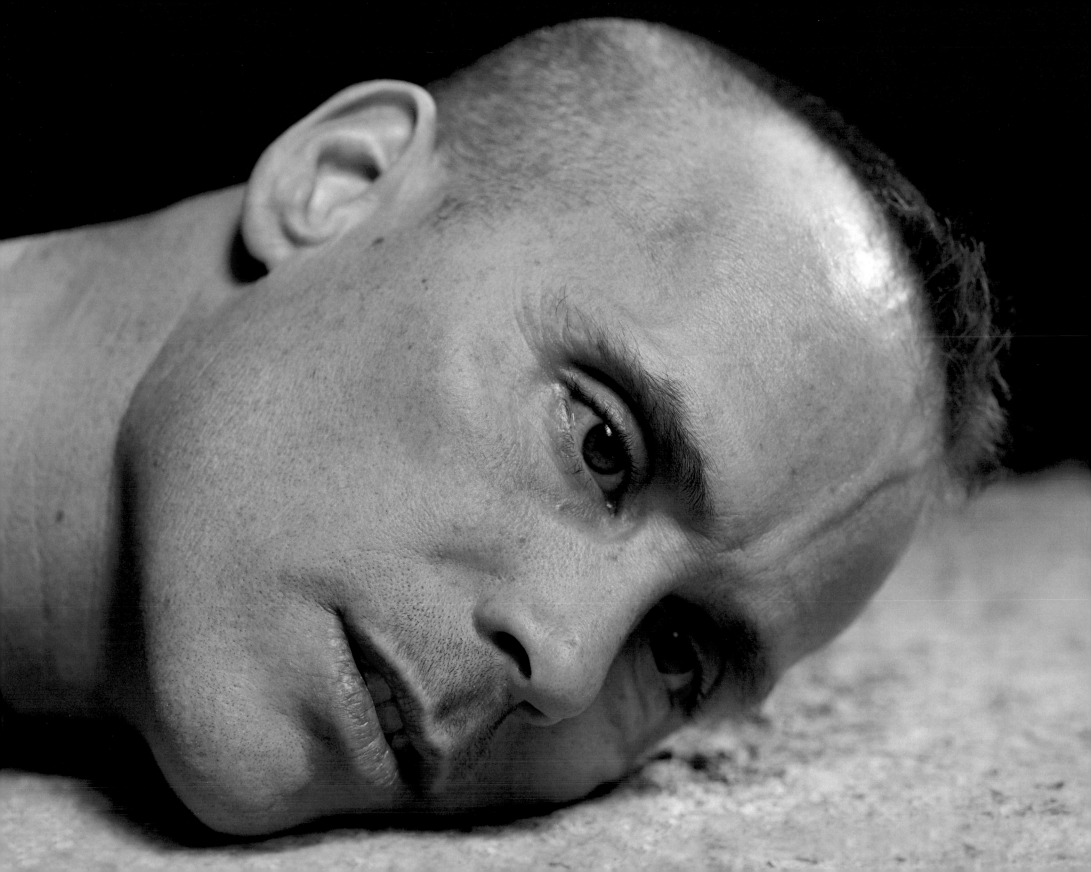

SOLDIER: DOUGHERTY 302 DAYS IN AFGHANISTAN

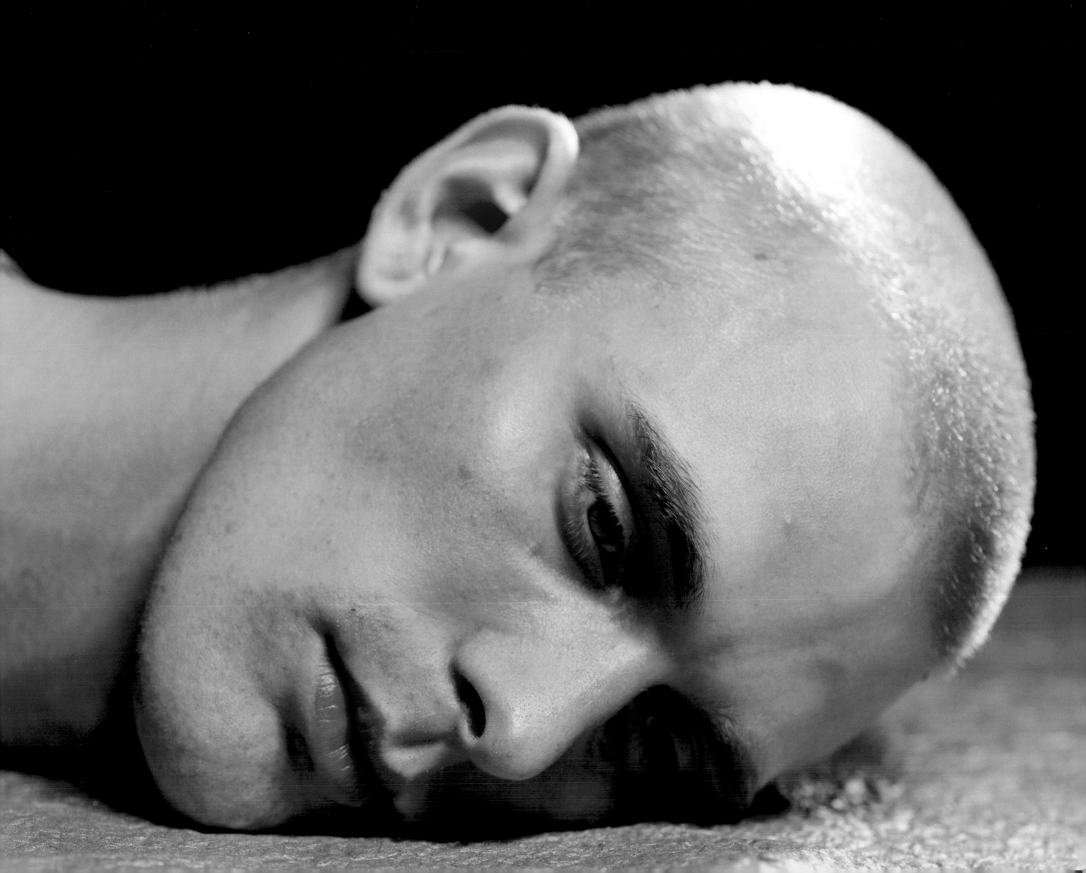

SOLDIER

I MADE THE *SOLDIER* PORTRAITS WITH THE COOPERATION OF
THE MILITARY AT FORT DRUM, NEW YORK. THESE SOLDIERS, WHO
VOLUNTEERED TO BE PHOTOGRAPHED, HAD COMPLETED ONE AND
SOMETIMES TWO TOURS OF DUTY IN IRAQ OR AFGHANISTAN.
THEY WOULD ALMOST ALL RETURN FOR MORE.

of the people she encounters. Photography, with its privileged reputation for objectivity, is one way to test that.

The texts that accompany Opton's photographs echo her desire to convey elusive narratives. In *Soldier,* each portrait appears with the sitter's last name, number of days, and place served. By providing quantifying information, Opton encourages the viewer to examine the relative effects of military mobilization. Can one see the difference between a long or short tour of duty? Is one theater of war more punishing than another? In *Many Wars,* portraits appear with full names, biographies, and personal statements by the sitter. This gives the pictures a cinematic edge, almost as though they are publicity shots for a macabre film. It also provides insight into the causes and manifestations of combat trauma. In Opton's work, text and image perform an intricate dance, each conveying elements of a story that can never be truly absorbed. This failure to connect fully is one of the reasons for their success. Closeness and distance are inextricably linked, as the viewer is brought face to face with people who are intensely real, but whose experiences are so far removed from quotidian concerns they are impossible to fully comprehend.

Opton does not see herself in the tradition of "therapeutic" photography used in mental hospitals. Yet her photographs do call to mind a long history of photography used in this way, beginning with the British physician Hugh Welch Diamond, who pioneered the use of photographic likenesses in the treatment of mental disorders in England in the 1850s. In Diamond's case, patients had their portraits done, and the results were shown back to them. It was hoped that the shock of realization this caused as the patients saw themselves in a "diminished" state would cause patients to spontaneously recover. The enduring appeal of these historical portraits lies in the way in which a particular condition was thought to be written into the face of the sitter. Although Opton's photographs were not made for medical purposes, they are equally magnetic. Like her Victorian predecessors, Opton attempts to reveal something about the inside of the sitter by showing us only the outside. What we see is skin, bones, and muscle. Yet we are impelled to consider thought and feeling.

Much of Opton's art lies in her ability to cleverly walk the line between providing and withholding visual information. Although her portraits are in a sense documentary, they are artfully constructed to convey just the right amount of detail. In *Soldier,* her soldiers are shown as they really are, never retouched or made up, with their acne and razor burns visible for all to see. At the same time, they are subtly ennobled, photographed against neutral backdrops, and artificially illuminated with dramatic studio lighting. In *Many Wars,* the palette shifts from one sitter to the next. Opton uses a quality of light and color inspired by Renaissance painting, giving each image a distinct mood. Like the nineteenth-century photographer Julia Margaret Cameron, Opton frequently photographs with shallow depth of field, allowing only a narrow plane of a sitter's face to come into focus. And like Cameron, she uses bold washes of shadow to charge her pictures with emotion. As when she takes an intimate picture of a soldier's head and enlarges it to the size of a billboard, Opton constantly sets up expectations, only to confound them. Her pictures are whispers, spoken through a megaphone.

Phillip Prodger, Ph.D. (Cantab.), is Curator and Head of the Photography Department at the Peabody Essex Museum in Salem, Massachusetts, which maintains one of the oldest and largest photography collections in the United States. He is the author and editor of numerous books including Time Stands Still, Hoppé Portraits: Society, Studio, and Street, Darwin's Camera, *and* Man Ray | Lee Miller, Partners in Surrealism.

Footnotes

1 Remarks of Senator Barack Obama, "The American Promise," Democratic National Convention, August 28, 2008, Denver, Colorado.

2 ibid.

3 Daniel Nasaw, "US Election: Billboards of US Soldiers Cancelled by Host City of Republican Convention," The Guardian, August 28, 2008. n.p.

4 See for example Vicki Goldberg, "On Guard: Soldiers Off Guard," Contact Sheet, March-June, 2006, pp. 2-4.

The controversy stirred by Opton's photographs increased during the Presidential election campaign of 2008. When she began photographing at Fort Drum some four years earlier, Opton could not have known that presidential candidate Barack Obama would engage some of the same subject matter in his acceptance speech at the Democratic National Convention. During his address, Obama explained that the spirit of the nation could be found in the faces of its citizens. "In the face of that young student who sleeps just three hours before working the night shift," he explained, "I think about my mom, who raised my sister and me on her own while she worked and earned her degree."[1] And "in the faces of those young veterans who come back from Iraq and Afghanistan, I see my grandfather, who signed up after Pearl Harbor, marched in Patton's army, and was rewarded by a grateful nation with the chance to go to college on the GI Bill."[2] Obama may not have realized it, but at that very moment, Opton's photograph *Soldier Claxton* hovered without explanation over the Denver skyline just a few blocks away. Installed on a billboard at Lincoln and 18th Streets, it showed exactly what Obama said had moved him—the face of a soldier who had served in Afghanistan.

It is unlikely then-Senator Obama would actually have recognized the face of his grandfather in Opton's photograph of Soldier Claxton, as his speech suggested. But if he had, he might not have admitted it to his supporters. The soldier of Obama's rhetoric was heroic, determined, and proud—the type of valiant soldier so often depicted in traditional military portraits. Claxton, by contrast, lies with his head almost flat, his face half bathed in shadow, and his eyes vacant. He is isolated, singular, and curiously beautiful—a physical presence, raw, human, and imperfect.

Republicans, who held their convention a week after the Democrats, would not have the same chance to reflect on Opton's portraits. Although she and Reynolds had planned to install five *Soldier* billboards in Minneapolis–Saint Paul during the Republican National Convention, the owner of the structures, CBS Outdoor, withdrew permission the week before they were supposed to be installed.

"Out of context," CBS vice president Jodi Senese explained, "the images, as stand-alone highway or city billboards, appear to be deceased soldiers. The presentation in this manner could be perceived as disrespectful to the men and women in our armed forces."[3] Eventually rival company Clear Channel agreed to rent their billboards for the purpose, but by that time the convention was nearly over.

Senese's concern that Opton's photographs might be seen as ruminations on death hint at the multifaceted readings possible in the *Soldier* series. With their subjects lying prone, they afford an intimate view that few ordinary people have of military men and women. As Senese suggests, they might be seen as the last glance of a mortally wounded soldier, or the look of a fallen hero on a mortuary slab. Alternatively, they could be interpreted as a prisoner about to be beheaded, a practice prevalent in Iraq at the time these pictures were made. Their pose also mirrors the position of a statuary head toppled from its pedestal, as when former Iraqi President Saddam Hussein's bronze likeness was brought down in Firdos Square, Baghdad, in April 2003. Yet there are other, less ominous interpretations. The same level view could be that of a bunkmate in barracks before lights out, or of a lover looking across an adjacent pillow. Or it could be that of a mother before tucking her child in at night.

Several writers have remarked on the similarities between Opton's *Soldier* photographs and the sculptures of recumbent heads that Constantin Brancusi produced in the 1910s.[4] Brancusi's sculptures, disembodied ivory-white stone heads lying on their sides, do have a similar ethereal appearance and use the same unusual pose—dissociated heads appearing like so much fruit in a still life. However, there is a critical difference. Unlike Brancusi, Opton has used photography to execute her pictures, with the empirical associations that entails. Despite its well-known susceptibility to manipulation, photography is still perceived largely as an objective medium, and its evidentiary function is critical to Opton's approach. Her photographs are in this sense evidence of *evidence*—the photograph records the person, while the person represents things that happened in another time and place. Opton explores whether the experience of war is written in the faces

at Veterans Administration medical clinics in Vermont. The individuals photographed were no longer in active service and most were suffering the lingering effects of various conflicts.

Although different in tone and style, each series reflects the artist's interest in portraying soldiers both as individuals and ambassadors from an unfamiliar world. Opton has never experienced front-line conflict herself. So to her, each soldier sent into battle is a sort of rhetorical Mars probe, forged by the unimaginable situations he or she has witnessed. Although injuries are not conspicuously apparent, the people she photographs are nevertheless marked, the subtleties of carriage and demeanor betraying what they have been through. Each face and every piercing set of eyes is a mysterious window onto occurrences far removed from civilian life.

Opton's photographs document performances she orchestrates. For the *Soldier* portraits, sitters were given the simple direction to sit in a chair and lay their head on a table. The reason this particular pose was selected is not explained, and the action must have been baffling to those depicted. Yet the interpretation of the unusual instruction gives the resulting pictures their power. Some sitters, like the soldiers the artist identifies as Kitchen, Bruno, and Kimball, strain to lift their heads. Others, like soldiers Pry, Neal, and Morris, relax and close their eyes as if in sleep or deep reflection. Tightly focused and with few environmental clues, every detail of the heads takes on heightened significance.

The photographs in *Many Wars* are also performative. Sitters were asked to pose wrapped in upholstery cloth provided by the artist. This serves to obscure the manner of dress of each sitter, giving the portraits egalitarian consistency. At the same time, the improvised uniform highlights differences in personality, as the way in which individuals hold the cloth is often markedly different. Pia Towle-Kimball wraps the cloth around her like a cocoon; Jim Dooley wears his like an imperial robe. Jay Wenk bundles his over the shoulder as if enacting the trials of a saint in an Old Master painting.

The decision to drape sitters in cloth was inspired in part by a historic photograph the artist collected, in which a group of American soldiers is seen camouflaged in white cloth against a snowy landscape during WWII. Supplied by local families, the camouflage was improvised from household table and bed linens. Growing up in Ebsdorf, Germany, just before the war, the artist's mother had studied embroidery and textiles herself, but when the conflict escalated and her family fled the country, she was forced to hide her production in a secret cache. Years later she retrieved the material, eventually giving it to her daughter. Opton hoped her mother's linen might enable her to re-enact the historic use of linen as camouflage, and began by inviting former soldier Cliff Austin to interact with the material. Ultimately, this proved unsatisfactory and the artist switched to a more neutral upholstery cloth.

As in most cultures, the image of the warrior in American society is intensely charged. Soldiers are meant to be fearless and resolute, whereas in Opton's pictures they appear vulnerable, personable, and ambiguous. Traditionally, military portraits show men of action: *Napoleon Crossing the Alps* by Jacques-Louis David, or *Washington Crossing the Delaware* by Emanuel Leutze. In such pictures the patriotic message is clear, and virtue is apparent. Opton inverts this established conceit, curbing any temptation towards pomp and self-congratulation. Whereas in traditional military portraits leaders look down from on high, replete with military garb and showy weapons, in Opton's pictures figures are shown close, at the same height as the viewer or slightly below, and stripped of décor. In place of nationalism, she invites compassion. Instead of zeal, she encourages contemplation.

To make her photographs, Opton cleverly co-opts conventions from the commercial world. Her pictures resemble fashion shots more than traditional war photographs, an association reinforced by the use of billboards to exhibit the *Soldier* work. The neutral backdrops, sharp focus (albeit with narrow depth of field), and pared-down use of props in her pictures parallel the methods of Richard Avedon, who sought to emphasize personality by minimizing extraneous information. The concordance with fashion photography contributes to the work's equivocal air, portraying serious subject matter with techniques normally identified with comparatively cheerful publications.

FALLEN

PHILLIP PRODGER

Suzanne Opton's *Soldier* photographs caused a sensation when they were displayed on billboards in numerous American cities beginning in autumn 2008. Working with curator Susan Reynolds, the two installed enlarged images from the series in Atlanta, Columbus, Denver, Houston, Miami, Minneapolis, and Troy, New York. This followed a related project in which some of the same photographs were shown in Syracuse and Buffalo on bus shelters, banners, and billboards, and climaxed in spring 2010 when a selection was exhibited on advertising sidings in the Washington D.C. Metro. On billboards, individual photographs were blown up as large as forty-eight feet wide, appearing only with the word "Soldier" in capital letters, accompanied with a web address where interested viewers could go to see further images and were invited to comment on them.

The artist started photographing soldiers in response to the second Iraq War, which began in 2003. However, she does not identify her photographs with a particular political party or cause. While they undoubtedly express unease about the toll combat can take on members of the armed forces, ironically it is their humanizing aspect that has proven most difficult for some to digest. Like the photographs themselves, the billboards were unclear in their meaning, calculated to provoke thought rather than make a specific political point. The large cryptic pictures became blank slates on which viewers could project their associations. Enlarged to supernatural size, they clearly said *something*. What that something might be became a matter of heated speculation. The photographs were quirky, intimate, and enigmatic, but the presentation was the opposite—overt, bold, and direct.

The empathy Opton has for American servicemen and women is evident in the two series of photographs reproduced in this book. They are a graphic expression of her intellect: the face is searched, and then sensitively preserved. *Soldier* features head-only color portraits of active-duty soldiers lying horizontally on a table, their faces largely filling the frame. They were taken in Fort Drum, New York, in 2004 and 2005 of soldiers who had served in the American wars in Iraq and Afghanistan. The second, *Many Wars,* is made up of three-quarter length portraits of men and women most of whom were participating in group therapy for Post Traumatic Stress Disorder

SUZANNE OPTON

SOLDIER

ESSAY BY
PHILLIP PRODGER

DECODE BOOKS